VERMEER

VERMEER

Martin Bailey

Phaidon Press Limited
Regent's Wharf, All Saints Street, London N1 9PA

First published 1995
Reprinted 1996, 1997, 1998
© Phaidon Press Limited 1995

A CIP catalogue record for this book is available from the
British Library

ISBN 0 7148 3463 7

Printed in Singapore

Cover illustrations:
Front: *A Lady Writing*, *c*1665 (Plate 27)
Back: *The Milkmaid*, *c*1658–60 (Plate 11)

The publishers would like to thank all those museum authorities and
private owners who have kindly allowed works in their possession to
be reproduced. Particular acknowledgement is made for the following: Plates 10, 17 and 35: reproductions © The Frick Collection, New
York; Plate 19 and Fig. 2: reproductions © Her Majesty Queen
Elizabeth II; Plates 21 and 30: Widener Collection, National Gallery
of Art, Washington, DC; Plate 24: bequest of Collis P Huntington,
Metropolitan Museum of Art, New York; Plate 27: gift of Harry
Waldron Havemeyer and Horace Havemeyer jun., in memory of their
father, Horace Havemeyer, National Gallery of Art, Washington,
DC; Plate 29: Andrew W Mellon Collection, National Gallery of Art,
Washington, DC; Plate 34: gift of Mr and Mrs Charles Wrightsman, in
memory of Theodore Rousseau jun., 1979, Metropolitan Museum of
Art, New York; Plate 44: Friedsam Collection, bequest of Michael
Friedsam, 1931, Metropolitan Museum of Art, New York.

Note: All dimensions of works are given height before width.

Vermeer

Johannes Vermeer of Delft (1632–75) was in his early years both an artist and an innkeeper. His tavern, The Mechelen, was in the Market Square and would have been a rowdy place to live and work (Fig.1). Downstairs in the drinking rooms, below his studio, the painter must have witnessed daily the sort of tavern scenes so graphically recorded by his contemporary, Jan Steen (1629–79). The paintings of Steen, who owned a brewery in Delft, are packed with peasants and soldiers, serving wenches and serenading musicians, pimps and prostitutes, cheating card players, naughty children and misbehaving dogs (Fig. 2). Although Vermeer sometimes portrays similar themes, evoking the pleasures of wine, women and song, his paintings could hardly be more different from Steen's exuberant works. In contrast, Vermeer usually concentrates on just one or two figures caught in a silent moment of reflection. His interiors are set in elegant rooms, tastefully furnished and fastidiously arranged. One suspects that Vermeer may have enjoyed painting as an escape, retreating upstairs to his studio to get away from the bustling market and the boisterous tavern. On canvas he was able to create a more poetic world than the one in which he lived, and at first glance his pictures convey great tranquility, although the viewer soon senses the tensions that lurk beneath the surface.

Vermeer was born in a tavern and during his childhood he must have had endless opportunities to observe the foibles of his fellow man. His father, Reynier Jansz Vos, was born in Delft in 1591. At the age of 20 Reynier set off for Amsterdam, where he became a weaver of caffa, a silk fabric. There, he fell in love and in 1615 married Digna Baltens, who originally came from Antwerp. The young couple then moved to Delft, where Reynier continued as a caffa weaver for a few years before becoming an innkeeper. He rented a tavern in the small street Voldersgracht. It was called The Flying Fox, presumably after his name Vos, meaning fox (only later did Reynier adopt the surname Vermeer).

Reynier, who seems to have had a shrewd eye for business, soon started another trade as a picture dealer. Running an inn and selling paintings may sound an incongruous combination, but a tavern would have provided a convenient place to get to know both artists and collectors. In 1631 Reynier was admitted to Delft's artists' guild, the Guild of St Luke, as a master dealer. Little is known about his picture business, but there is some evidence that he built up quite a respectable stock. The Delft artist Leonaert Bramer (1596–1674) made an album of sketches of paintings in 11 local collections and Reynier's pictures were considered important enough to include (Fig. 3).

Reynier and his wife, Digna, had only two children. The girl, Gertruy, was born in 1620, but their son was not born until 12 years later. He was christened Joannis in Delft's New Church on 31 October 1632, presumably a few days after his birth (he is now more usually

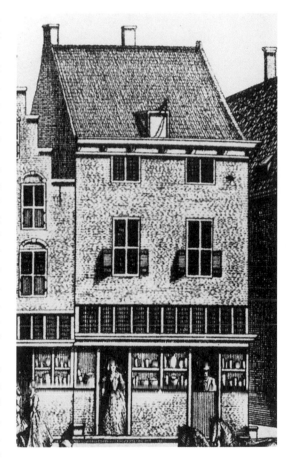

Fig. 1
L Schenk
The Mechelen
(detail of View of
Market Place)
c1720. Engraving after
drawing by Abraham
Rademaecker.

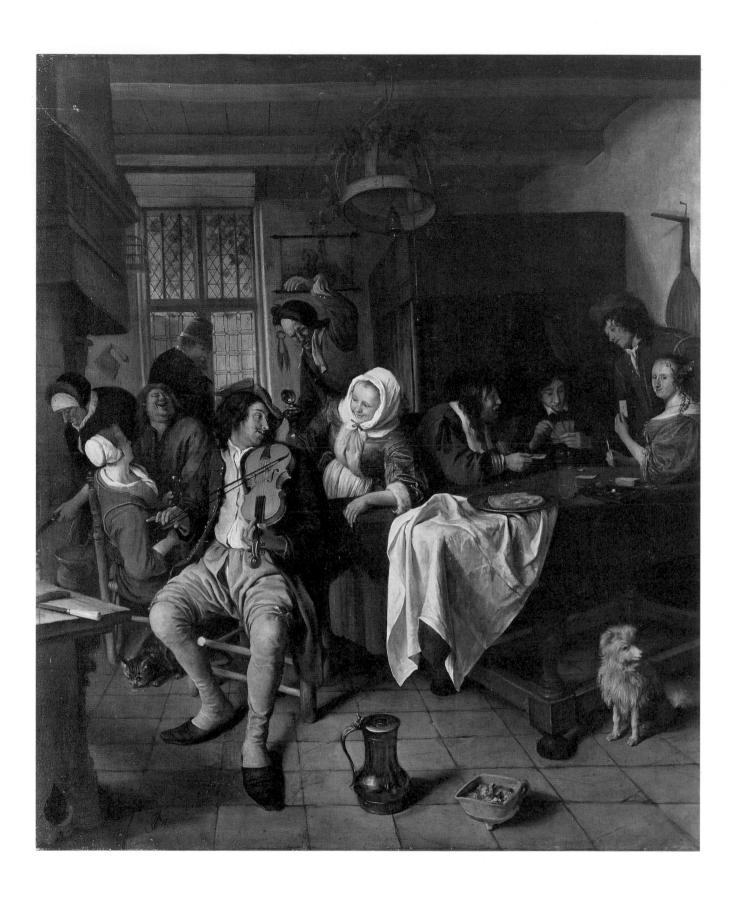

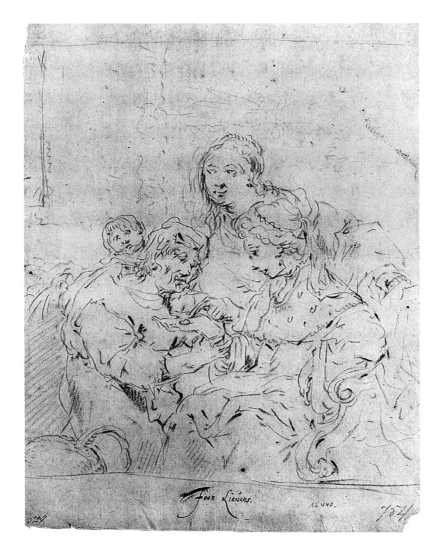

Fig. 2
JAN STEEN
Inn with Violinist and
Card Players
c1665–8. Oil on canvas,
82 x 69 cm.
Royal Collection

Fig. 3
LEONAERT BRAMER
The Fortune Teller
(after Jan Lievens)
c1652. Black chalk on
paper, 40.5 x 30.6 cm.
Kupferstichkabinett,
Staatliche Museen zu
Berlin – Preussischer
Kulturbesitz, Berlin

known as Johannes or Jan). The family continued to live in The
Flying Fox until 1641, when Reynier was doing sufficiently well to
take a mortgage to buy The Mechelen. This large inn, named after the
town between Brussels and Antwerp, stood on the north side of the
Market Square (Fig. 1).

Reynier's new tavern was in the very heart of Delft, then an impor-
tant provincial trading town in the Netherlands with a population of
25,000. Directly in front of The Mechelen lay the market, which must
have supplied a steady stream of thirsty customers. Just to the left was
the New Church, a large Gothic building dating from the fifteenth
century. To the right, further down the square, was the ornate town
hall, built in 1618 (Fig. 4). This area can be seen in a painting by Carel
Fabritius (1622–54) (Fig. 5): in the centre of the picture is the New
Church, to the left in the distance is the town hall, and The Mechelen,
although hidden in the painting, would lie directly behind the church.
The neighbourhood was pithily described by the diarist Samuel
Pepys, who visited Delft on 18 May 1660. He wrote about 'the great
church, that stands in a fine great market-place, over against the town
hall'. Pepys concluded that Delft 'is a most sweet town, with bridges
and a river in every street', a description that is equally applicable
today.

As a boy, Vermeer probably helped out in his father's tavern, which
served a predominantly middle-class clientele. His family was small,
so his parents could afford to educate him and they almost certainly
sent him to school for several years since he learned to read and write.
Presumably his interest in art must have developed as he saw the

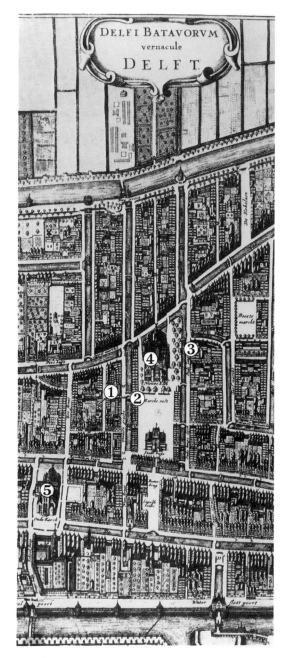

Fig. 4
WILLEM BLAEU
Map of Delft (detail)
1649. Engraving.
From *City Atlas of the
Netherlands* (Amsterdam,
1649)

KEY
① The Flying Fox
② The Mechelen
③ House of Maria Thins
④ New Church
⑤ Old Church

pictures which his father sold and met the artists who supplied them.

Training to become an artist normally took six years, and Vermeer probably started his apprenticeship at the age of 13 or 14. There has been considerable speculation about where he was trained. The names of a number of masters have been proposed, including Bramer, Fabritius and Evert van Aelst (1602–57), but Vermeer's early work does not reflect any of their styles. Another possibility is that Vermeer served his apprenticeship in another Dutch town, perhaps Utrecht or Amsterdam, both of which were leading artistic centres. He might, for example, have trained in the Utrecht workshop of Abraham Bloemaert (1564–1651), whose work is closer to Vermeer's early style. This theory is given strength by the discovery that Bloemaert was distantly related to Vermeer's future wife, which might explain how the couple met.

The young artist probably courted Catharina Bolnes at around the time when he was finishing his apprenticeship, at the age of 19 or 20. Catharina was born in Gouda in 1631 and had moved to Delft ten years later, following the divorce of her mother, Maria Thins. Initially Maria opposed her daughter's wish to marry Vermeer. She and Catharina were Catholics – a minority in Delft – and the Vermeers were Calvinists. Also, Maria had considerable inherited wealth and may have felt that the marriage would be a step down for her daughter. Vermeer persevered and tried to win's Maria's agreement to the match. On 4 April 1653 he asked the painter Bramer, who was a good family friend, to accompany him on a mission to see Maria. Bramer, a Catholic himself, must have assured her that the young artist had a promising future. Vermeer also agreed to convert to Catholicism and although Maria would not approve the match, she agreed not to oppose the marriage.

Vermeer was 20 and Catharina a year older when the wedding took place on 20 April 1653 in the church at Schipluy, a Catholic village just south of Delft. The young couple settled in The Mechelen. Reynier, Vermeer's father, had died in October 1652, six months before his son's wedding, but his widow, Digna, continued to run the tavern. A year after the marriage the Vermeers' first child, Maria, was born.

Vermeer had probably completed his apprenticeship shortly before his marriage and on 29 December 1653 he was admitted to the Guild of St Luke as a master painter. Frustratingly little biographical information about his professional life survives. There are no letters or writings by the artist, no sales records from his lifetime and only three extremely short contemporary references to his artistic fame. Furthermore, almost nothing was written about him for two centuries after his death. Nevertheless, archival detective work has revealed tantalizing glimpses into his life, thanks in particular to a series of discoveries by Professor John Montias.

Although Vermeer and Catharina spent their early married years in The Mechelen, by 1660 they had moved to the nearby house of Catharina's mother. Maria lived across the Market Square in Oude Langendijck, part of the Catholic area known as Papist's Corner. In Fabritius's painting of Delft (Fig. 5), her house would have been further down the street on the left, a few doors beyond the building with the hanging sign. Maria lived almost next to the Jesuit Church, a 'hidden church' whose exterior looked like an ordinary house. In a drawing of the church (Fig. 6) two figures are standing outside the main entrance, and the house at the far right, only the edge of which is depicted, was probably Maria's home.

We can only speculate about the reasons for the move to Maria's house. Vermeer may simply have wished to escape from the noisy tavern. His growing number of children probably meant that the

family needed more space, and Maria had a large, comfortable house in which she lived alone. Catharina may also have been concerned about raising her children in the Protestant part of town and felt that a home in the Papist's Corner would be more suitable. Vermeer had financial problems because his output of paintings was so low, and it is likely that Maria helped to support her growing number of grandchildren.

The Vermeers had at least 11 children during their 22 years of marriage: Maria, Elisabeth, Cornelia, Aleydis, Beatrix, Johannes, Gertruyd, Franciscus, Catharina, Ignatius, one other, and possibly more who died in infancy. From what we know of their later lives, none of them seem to have inherited Vermeer's artistic skills or pursued distinguished careers. Vermeer's wife, Catharina, who must have been pregnant for much of the time, also had the burden of looking after her mother. Although Maria lived to be 87, surviving Vermeer, she was already nearly 70 when the family moved in and was presumably getting frail. Caring for 11 children, an ageing mother, and an artist must have taken most of Catharina's time, even with the help of a maid. After Vermeer's death, she claimed to have known little about his business affairs 'since she had never concerned herself further or otherwise than with her housekeeping and her children'.

Vermeer seems to have spent his entire working career in Delft, where he was strongly influenced by the artistic milieu. Fortunately, when Vermeer qualified as a master painter, the town was truly entering its Golden Age and there was an astonishing number of talented painters working in a wide variety of styles. Bramer, who had earlier spent many years in Italy, had been the most important Delft artist in the 1640s, specializing in pictures of religious and mytho-logical subjects, known as history paintings. Vermeer had known him well enough to ask for his intervention over his bethrothal to Catharina. Evert van Aelst, a still-life painter of silverware and fruit, was also a family friend of the Vermeers. Among Evert's students was his more talented nephew, Willem van Aelst (1625–83), Anthonie Palamedesz (1601–73) was another of the established Delft artists, specializing in 'merry company' pictures of carousing soldiers and their ladies. Paulus Potter (1625–54), the painter of animals, joined the Delft guild in 1646, although he seems to have worked mainly in The

Fig. 5
CAREL FABRITIUS
View of Delft
1652. Oil on canvas,
15 x 32 cm.
National Gallery, London

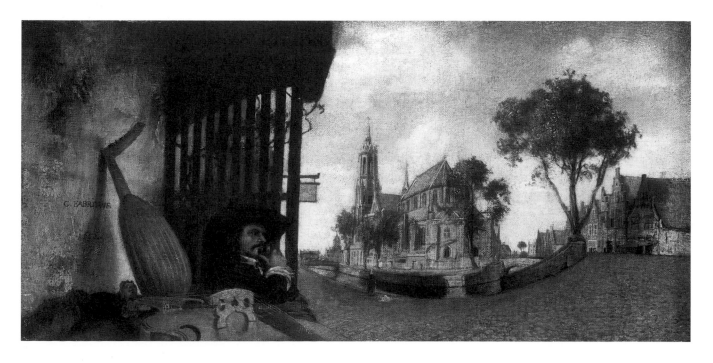

Fig. 6
ABRAHAM
RADEMAECKER
The Jesuit Church
Early eighteenth century.
Pen and ink on paper,
16 x 23 cm.
Gemeente Archief, Delft

Hague. Adam Pijnacker (*c*1621–73), who came from the nearby town of Schiedam, worked in Delft between 1649 and 1651 producing Italianate landscapes.

The greatest of the newcomers to Delft was a pupil of Rembrandt (1606–69), Carel Fabritius, who moved there in 1650. Vermeer must have admired his work, since he later owned at least three of his pictures. Tragically, Fabritius was killed in the gunpowder explosion which devastated the northern part of the town on 12 October 1654. This disaster was graphically recorded in several paintings by Egbert van der Poel (1621–64) (Fig. 7), who was distantly related to Vermeer's mother, Digna.

Other Delft artists recorded the glorious buildings which survived in the centre of the town. Gerard Houckgeest (*c*1600–61) and Emanuel de Witte (1618–92) both did paintings of church interiors, often including chattering worshippers and playful children (Figs. 8 and 9). Jan Steen, the Leiden artist who was renowned for his lively tavern scenes, was given a brewery in Delft by his father in 1654 and stayed in the town for a few years. Among his works from this period is *The Burgher of Delft and his Daughter* (Fig. 10), showing a wealthy citizen being approached for alms outside his house. Jan van der Heyden (1637–1712) visited Delft and one of his townscapes is of the Old Church (Fig. 11).

The artist who was to have the strongest influence on Vermeer was Pieter de Hooch (1629–84), who married in Delft in 1654 and joined the Guild of St Luke the following year. His interior scenes of drinkers had an important impact on Vermeer's pictures, and both artists tackled similar compositions, such as street scenes with views into courtyards. By the time De Hooch left Delft in 1661, Vermeer had overtaken him in skill and was influencing his work.

Four other artists working outside Delft also had a significant influence on Vermeer, all of whom specialized in genre paintings (subjects of everyday life). Gerard Dou (1613–75), from Leiden, was famous for small, meticulously executed pictures, known as 'fine' paintings; his greatest pupil was Frans van Mieris (1635–81). Gerard ter Borch (1617–81), who travelled extensively and was probably a friend of Vermeer, developed the idea of depicting individual figures and conveying their reactions to an event such as the arrival of a letter or a visitor. Archival evidence indicates that on 22 April 1653 both men served as witnesses for a legal document in Delft. This was just two days after Vermeer's wedding, which suggests that Ter Borch might have been invited for the occasion. The other genre painter who had

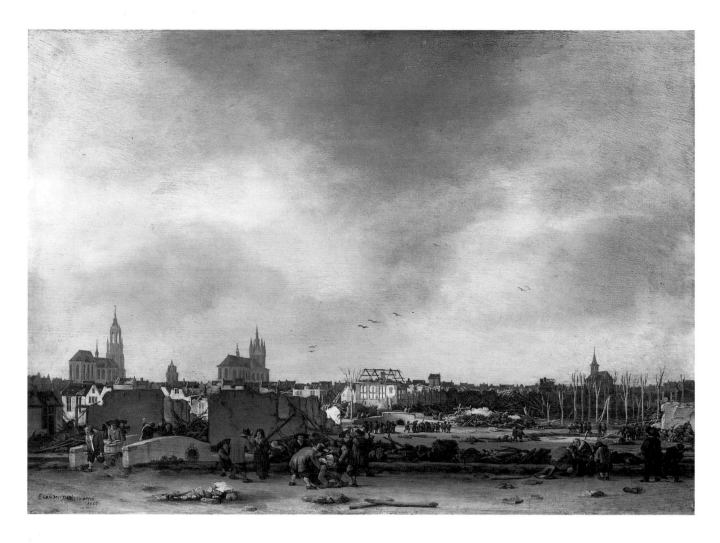

an impact on Vermeer was Gabriel Metsu (1629–67), who was based in Leiden and Amsterdam. Van Mieris, Metsu and Vermeer were all genre painters of the same generation, influencing each other's work, but eventually Vermeer would emerge as the greatest of them because of his subtlety and psychological insight.

Vermeer soon became a respected member of the talented circle of artists in Delft. In the autumn of 1662 he was one of the two painters elected as a Headman of the Guild of St Luke for two years, an honour for an artist who was only 30; in 1670 he was re-elected to the position for a further two years. Serving as a guild official would have brought Vermeer into close contact with its members and given him the opportunity to see a wide range of their work.

Vermeer's very early paintings are quite different from his later masterpieces. The three surviving pictures dating from his first two years as a master are of religious or mythological subjects. The earliest painting, *Christ in the House of Martha and Mary* (Plate 1), would never have been suspected of being a Vermeer had it not been for his distinctive signature. The painting was sold for £8 in around 1900 and the following year it was identified as a Vermeer, when the artist's signature was discovered on the stool on which Mary sits in the bottom left corner. Dated 1655, and only attributed to Vermeer in 1969, *St Praxedis* (Plate 2) is a copy of an Italian picture by Felice Ficherelli (1605–c1669) (Fig. 17). St Praxedis was revered by the Jesuits for having cared for Christian martyrs and Vermeer's painting is evidence of his conversion to Catholicism. The other early work, *Diana and her Companions* (Plate 3), is based on the legend of the Roman goddess of hunting.

Fig. 7
EGBERT VAN DER POEL
View of Delft after the Explosion
*c*1654–5. Oil on panel, 36 x 50 cm.
National Gallery, London

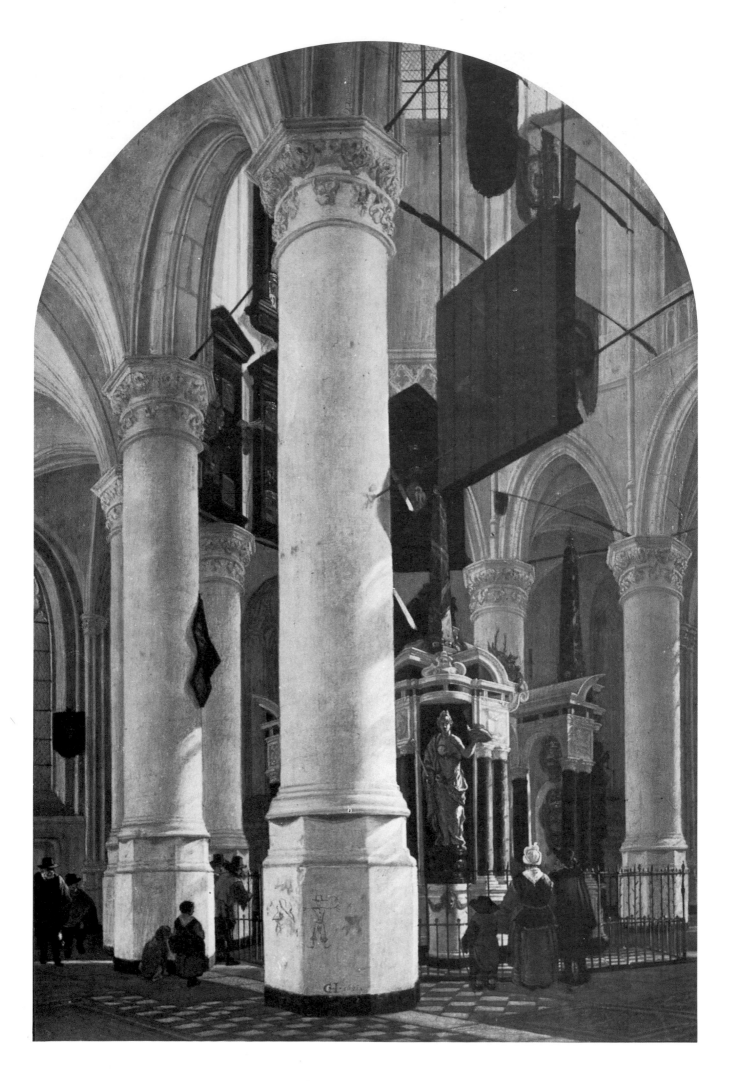

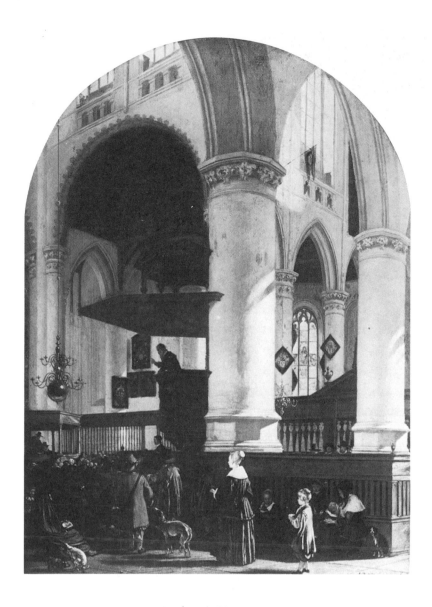

Fig. 8
GERARD HOUCKGEEST
Interior of the New
Church in Delft
1651. Oil on panel,
78 x 66 cm.
Mauritshuis, The Hague

Fig. 9
EMANUEL DE WITTE
Interior of the Old
Church in Delft
1651. Oil on panel,
61 x 44 cm.
Wallace Collection, London

The Procuress (Plate 4), dated 1656, is the first work in which Vermeer's later choice of subject-matter begins to emerge. Watched by the procuress, the soldier places his arm possessively around the girl, while proffering a coin with his other hand. On the left side of the picture, a man holding a cittern and a glass stares out at the viewer with a knowing grimace; this figure is thought to be a self-portrait of the young Vermeer (Fig. 12). Although the incident enacted in *The Procuress* could hardly be more blatant, *A Girl Asleep* (Plate 6), painted soon afterwards, displays some of the ambiguity which characterizes Vermeer's later work. Resting her head on her arm, the young woman's eyes are closed yet it is not clear whether she is asleep or awake, dreaming or thinking, sober or drunk. Vermeer has created a realistic interior space with a view beyond into an empty room, and the picture intrigues, drawing the viewer into the girl's private world.

From here onwards it becomes more difficult to trace the chronological sequence of Vermeer's work. Only a much later pair of paintings are dated: *The Astronomer*, 1668 (Plate 36) and *The Geographer*, 1669 (Plate 38), although it is possible that both dates were added after Vermeer's death. The task of establishing the chronology is complicated further by the fact that so little bio-graphical information about Vermeer's life survives and it is therefore necessary to try to reconstruct the order of the pictures by considering subject-matter and the artist's stylistic evolution. The dates given in this book are those cited in Arthur Wheelock's 1988 monograph,

13

updated where necessary in the light of more recent research.

One of Vermeer's favourite early subjects is young women drinking in the company of gallant men. These pictures include *Officer and Laughing Girl* (Plate 10), *The Glass of Wine* (Plate 13) and *The Girl with Two Men* (Plate 14). Although these scenes take place in elegant interiors rather than bawdy tavern rooms, the suggestion of a strong link between drink and seduction is always present.

Girl Reading a Letter at an Open Window (Plate 7) introduces a motif that was to become a favourite of Vermeer, a woman engrossed in reading a letter, presumably from her lover. In his pictures of young women reading or writing love letters, the subjects are always deep in concentration, their eyes turned away from the viewer so that they betray little about their intimate feelings. Vermeer frequently returned to this theme: *Woman in Blue Reading a Letter* (Plate 18), *A Lady Writing* (Plate 27), *Mistress and Maid* (Plate 35), *The Love Letter* (Plate 39) and *Lady Writing a Letter with her Maid* (Plate 43).

The Little Street (Plate 8) is quite unlike Vermeer's earlier works in that it is a realistic townscape. It was once assumed that it portrayed the street at the back of The Mechelen, showing the view from the window of the artist's studio. However, a close study of town plans suggests that this is unlikely, and the scene may well be imaginary. Even if the pair of houses in *The Little Street* existed only in Vermeer's mind, his depiction of elements of Delft architecture is authentic, and the painting gives a marvellous picture of life in the back streets. Vermeer's only other townscape is on a quite different and monumental scale. *View of Delft* (Plate 15) is a panoramic view of the walled town across the River Schie. Set under a dramatic sky with rising storm clouds, the ramparts and the canal bridge are in shadow, while the spire of the New Church in the Market Square is illuminated by a shaft of sunlight. Although it appears to be an accurate topographical record, a detailed study of the picture reveals that the artist modified elements to improve his composition.

The major theme of Vermeer's later work is the figure of a woman playing music, often with a male accompanist or listener. Judging by his repeated depiction of these scenes, Vermeer seems to have enjoyed music. It was an important part of tavern life and there were probably several instruments in his home, including a virginal (a type of harpsichord) and a viol. Among Vermeer's paintings where music plays an important role are *Girl Interrupted at her Music* (Plate 17), *The Music Lesson* (Plate 19), *Woman with a Lute* (Plate 24), *The Concert* (Plate 31), *The Guitar Player* (Plate 45), *A Lady Standing at the Virginal* (Plate 46) and *A Lady Seated at the Virginal* (Plate 48). In Vermeer's time musicmaking was regarded as symbolizing the harmony of love and a lover was compared with a musical instrument, whose strings or keys were touched by their beloved.

Vermeer usually portrays women suspended in a moment of time, consumed by their thoughts. Sometimes they are concentrating on an activity, such as *The Milkmaid* (Plate 11), *Woman Holding a Balance* (Plate 21), *Woman with a Pearl Necklace* (Plate 23), *Young Woman with a Jug* (Plate 25) and *The Lacemaker* (Plate 41). Others are simple portraits, such as *The Girl with the Pearl Earring* (Plate 26), *Girl with a Red Hat* (Plate 29), *Girl with a Flute* (Plate 30) and *Head of a Young Woman* (Plate 34).

It is tempting to speculate whether Vermeer's wife, Catharina, ever posed for his paintings. The plump figure in *Woman in Blue Reading a Letter* (Plate 18) could well be pregnant and it has been suggested that it could be Catharina. One also wonders if she might be the subject of *Woman with a Pearl Necklace* (Plate 23), one of the few paintings which

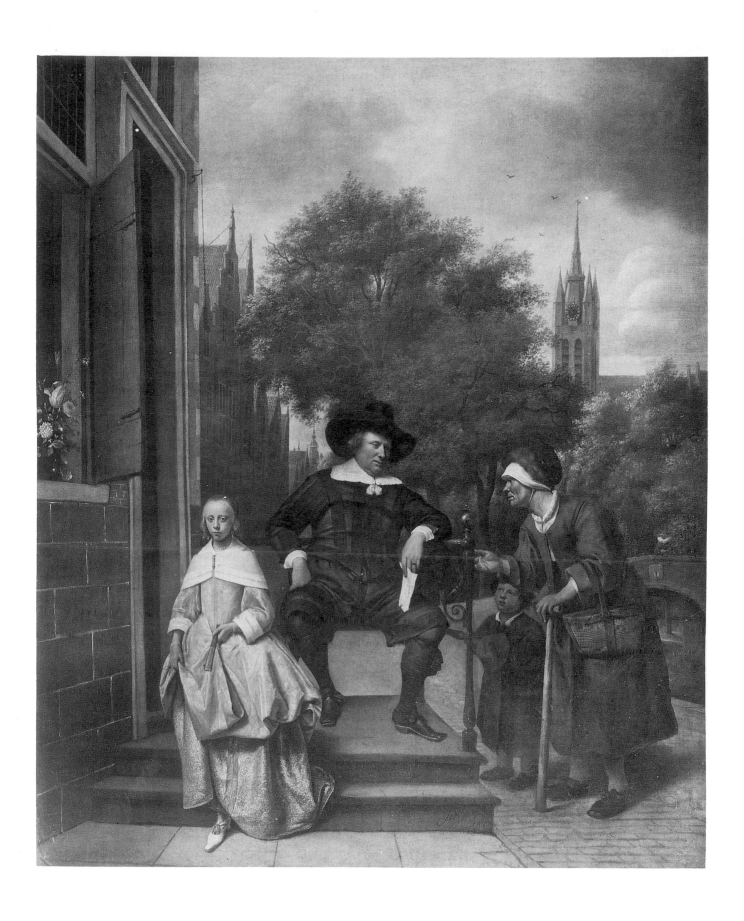

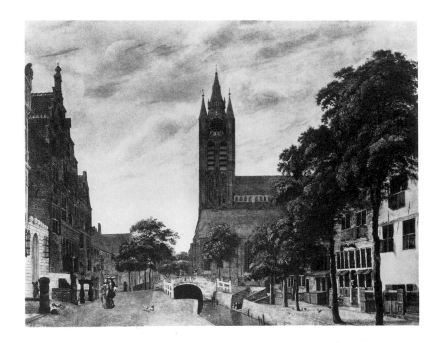

Fig. 11
JAN VAN DER HEYDEN
Old Church in Delft
*c*1700. Oil on panel,
55 x 71 cm.
Detroit Institute of Arts,
Detroit, MI

Vermeer kept until his death. However, this is mere speculation and the tantalizing question remains unanswered.

Although Vermeer must always have been surrounded by children, they never appear in his paintings of interiors. The only young children in his pictures are two small figures playing outside in *The Little Street* (Plate 8) and a tiny infant held in its mother's arms on the quayside in *View of Delft* (Plate 15). It is unclear whether the girls in Vermeer's portrait heads depict actual people or idealized faces and they are also of a rather indeterminate age. It has been suggested that *Head of a Young Woman* (Plate 34) might represent Vermeer's eldest daughter, Maria, who would probably have been a young teenager at the time, but there is no evidence to support this attractive theory.

Vermeer's paintings observe women, either alone or with a male companion. Men normally play a secondary role in his pictures and hold a prominent position in only two works: *The Astronomer* (Plate 36) and *The Geographer* (Plate 38). These are a pair, and because of Vermeer's lack of interest in depicting men, one assumes that they were commissioned by the scholar who appears in them, possibly identifiable as the Delft scientist Anthony van Leeuwenhoek.

Vermeer painted two allegories. *The Art of Painting* (Plate 32) depicts an artist in his studio, perhaps Vermeer himself (Fig. 13), in the process of painting Clio, the Muse of History. This painting, which conveys the message that the artist gains inspiration from history, is arguably his greatest masterpiece. This marvellous picture was followed by a much less successful work, *Allegory of Faith* (Plate 44), which was probably commissioned by a Catholic patron.

These pictures comprise the 36 surviving paintings by Vermeer. For most of the pictures the attribution to Vermeer is now universally accepted, although in one case, *Girl with a Flute* (Plate 30), there are serious doubts and in three other cases, *St Praxedis* (Plate 2), *Woman with a Lute* (Plate 24) and *Girl with a Red Hat* (Plate 29), the attributions are questioned by some scholars. There are also nine Vermeers listed in seventeenth-century inventories and sales, which are presumed lost: an early religious picture, *The Visit to the Tomb*; a townscape, *A View of a House Standing in Delft*; two interiors, *A Gentleman and a Young Lady Making Music in a Room* and *A Gentleman Washing his Hands in a Room with Sculptures*; an intriguing self-portrait, *The Portrait of Vermeer in a Room with Various Accessories Uncommonly Beautifully Painted by him*; and

four portraits. A few other pictures by Vermeer were probably lost and remain unrecorded. He is unlikely to have completed more than about 50 major works as a master, which means that he painted just two a year, unlike prolific painters who may have produced dozens a year, usually with the help of assistants. Vermeer never seems to have run a workshop and trained apprentices. His low output and the fact that so few pictures have been found in a style close enough to his to be by pupils, suggest that he worked very much by himself.

Vermeer was painstaking in his work and his compositions are very carefully planned. He was obviously concerned about perspective and went to great efforts to give an impression of depth in his interiors. Tiled floors and the skilful positioning of furniture were used to create a realistic representation of a three-dimensional room. It is also believed that Vermeer used a camera obscura to help him compose his pictures. This instrument, which was developed in the sixteenth century as an aid to drawing, projects an image through a lens onto a screen or sheet of paper; it works on a similar principle to a modern camera but without the use of a film. Some of the effects of a camera obscura must have interested Vermeer, such as its exaggerated perspective, heightened colours and contrasts, and the diffused highlights that occur in the unfocused area of an image. However, Vermeer only used a camera obscura as a guide, and not to produce a precise representation of a scene.

There are no surviving drawings attributed to Vermeer, but it is likely that he did make preliminary sketches which have since been lost. His early paintings, which are generally much larger in size than his later works, were painted with fluid brushstrokes. In his middle years, both colours and lighting become more muted, as efforts are concentrated on evoking a poetic atmosphere. Towards the end of his life his pictures become slightly more polished in execution, probably reflecting the growing popularity of the 'fine' painters, who were renowned for their meticulous attention to detail.

Vermeer's studio in the house owned by his mother-in-law, Maria, where he lived for most of his working life, was on the upper floor in the front. According to an inventory made soon after his death, its contents included: two easels, three palettes, six panels, ten canvases, an ivory-knobbed stick (probably a maulstick used for steadying the hand while painting), three bundles of prints, a desk, an oak table, two Spanish chairs and a cupboard with drawers. In the attic was a stone slab for grinding colours and in a back room were 25 books and five folio volumes; this was quite a considerable library for the time and evidence that Vermeer must have read widely. It is tempting to see *The Art of Painting* (Plate 32) as a depiction of Vermeer's own studio, as the design of the interior and its furnishings are likely to include some elements from the room where it was produced. Nevertheless, it is not a literal depiction of Vermeer at work; a slitted jacket and beret are hardly ideal painting clothes, and few artists would start to paint a head by depicting the laurel-leaf garland which is to crown it.

Most of Vermeer's paintings are of interiors and similar features in these recur: the leaded, mullioned window through which the sunlight streams, the black and white marble floor tiles, the row of Delft tiles along the skirting, and the beamed ceiling. Equally familiar are the distinctive chairs with lion-head finials, the Oriental rug covering a table and the white ceramic wine pitcher. Even the clothing of the figures seems likely to have come from the family wardrobe; the elegant 'yellow mantle trimmed with white fur', listed in the 1676 inventory of Catharina's possessions, appears in no less than six

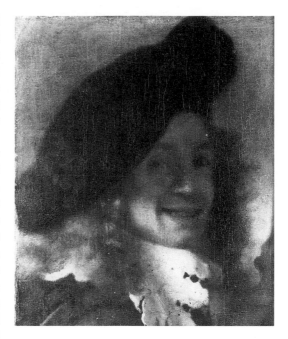

Fig. 12
Probable self-portrait of Vermeer (detail of Plate 4)

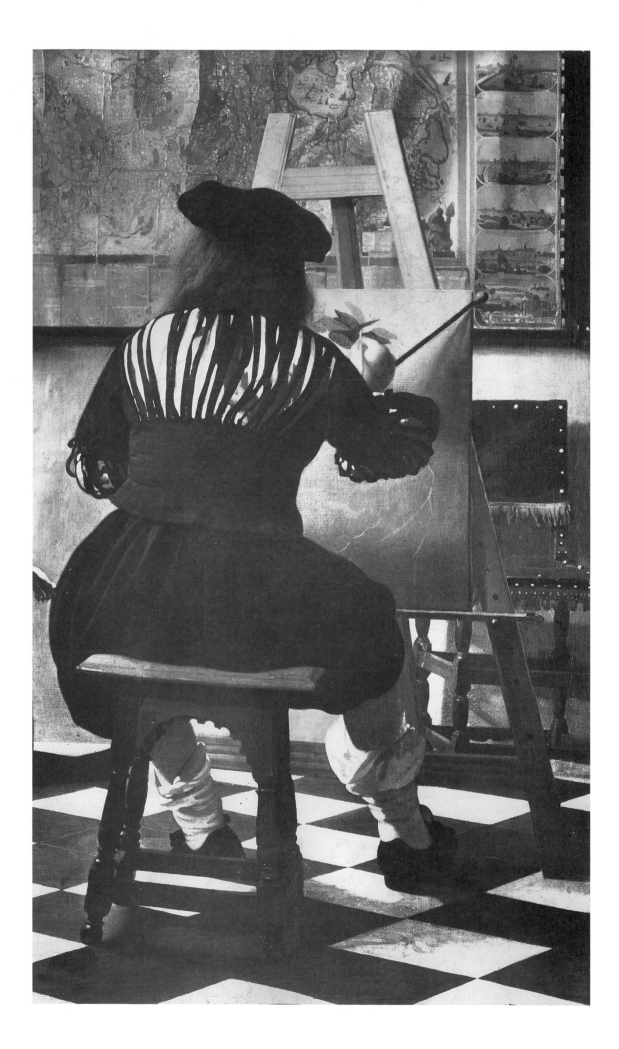

paintings. However, a careful observation of these objects reveals subtle alterations from painting to painting. The chairs with the lion-head finials, which are probably the 'two Spanish chairs' listed in the inventory, are depicted in a series of early pictures with their leather backs decorated with a pattern of yellow lozenges, such as in *Officer and Laughing Girl* (Plate 10). In the later picture *Woman in Blue Reading a Letter* (Plate 18) the chairs reappear covered with light-blue velvet. The chairs might have been reupholstered, but the yellow lozenges recur once again a few years later in *A Lady Writing* (Plate 27). The artist probably simply altered the backs of the chairs to suit his composition. Other objects that alter include the yellow mantle (which is blue in two paintings) and the marble floor tiles (which have a design of black crosses in six pictures and white crosses in another).

Just as Vermeer manipulated certain objects in his house to suit his compositions, so too did he alter the pictures which hang on the walls of his interior scenes. These little paintings were included partly for decoration, but often they were there to emphasize a particular moral point. *The Procuress* (Fig. 30), a work by Dirck van Baburen (*c*1595–1624) which was owned by Vermeer's mother-in-law, Maria, is first depicted framed in black ebony in the background of *The Concert* (Plate 31). In *A Lady Seated at the Virginal* (Plate 48), completed about eight years later, it is portrayed in a gold frame. Although it is possible that *The Procuress* was reframed by Maria, it is more likely that Vermeer wanted a glittering highlight in the background behind the woman playing the virginal. In *Allegory of Faith* (Plate 44), Vermeer made a compositional change in his depiction of *Crucifixion* by Jacob Jordaens (1593–1678) (Fig. 35), which appears in the background. He probably owned a version of the Jordaens which he used as a basis, but he omitted two figures from the painting which would have diverted the eye from the head of Faith. Not only did Vermeer feel free to alter the configuration of floor tiles to make them more appropriate for his composition, but even the work of a great artist such as Jordaens.

Vermeer's beautifully composed paintings of interior scenes brought him success, in that he appears to have sold nearly everything he produced. On his death, it seems that only four of his pictures remained in the house. For many years art historians have puzzled over where his pictures went, but it is now possible to identify the patron who must have bought almost half of Vermeer's entire *œuvre*. It has long been known that 21 Vermeers were sold in 1696 after the death of Jacob Dissius, a Delft bookseller and printer. Archival evidence reveals that Dissius inherited the pictures from his father-in-law, Pieter van Ruijven, who seems to have bought them directly from Vermeer. In 1657 Van Ruijven had lent Vermeer and Catharina 200 guilders, which might have been an advance payment for one or more paintings. When Van Ruijven's wife, Maria, wrote her will in 1665 she bequeathed 500 guilders to Vermeer in the event that she survived her husband. This was her only bequest to a non-family member and presumably represented a sign of friendship or patronage. In 1670, when Vermeer's dying sister, Gertruy, made her will, Pieter van Ruijven was one of the witnesses.

Van Ruijven died in 1674 and his wife, Maria, in 1681. Their property passed to their daughter, Magdalena, who had recently married Jacob Dissius. After Magdalena's death two years later, an inventory of goods inherited by her husband included 20 pictures by Vermeer. Dissius died in 1695 and when his collection was auctioned in Amsterdam on 16 May 1696, 21 paintings were sold (either the inventory was inaccurate or another picture had been acquired since it was compiled). The pictures, advertised as 'extraordinarily vigorously

Fig. 13
Probable self-portrait of Vermeer (detail of Plate 32)

and delightfully painted', fetched prices ranging from 17 guilders for a portrait head to 200 guilders for *View of Delft* (Plate 15). These were respectable prices, but less than those commanded by the very popular artists of the day. Altogether the 21 Vermeers sold for 1,503 guilders; 14 of the paintings survive today and seven have been lost.

The identification of Vermeer's major patron raises the intriguing question of the extent of his influence on the artist's work. Van Ruijven was born in Delft in 1624, making him eight years older than Vermeer. His father owned a brewery and his mother came from a rich patrician family. Van Ruijven, who seems to have lived off inherited wealth, had a house on the east side of the Oude Delft canal, close to the Market Square. He was probably a Remonstrant (a liberal Protestant) and for the last six years of his life he served as master of the Delft Charity Commissioners. As Van Ruijven provided Vermeer with a loan or advance payment in 1657, it is likely that he started to buy his work early on in his career. Having ultimately acquired 20 Vermeers by 1674, he must have been buying them at the rate of about one a year, which raises the possibility that it could have been a regular annual arrangement.

Despite Vermeer's success in selling his work, he always seems to have suffered from financial difficulties due to his slow production. Assuming that he completed only two major pictures a year, and each sold for several hundred guilders (a good price at the time), his income would have been small for a family which eventually included 11 children. No doubt Vermeer also suffered a loss of reliable income after the death of Van Ruijven in August 1674, and on 20 July 1675 he travelled to Amsterdam in order to borrow 1,000 guilders from the merchant Jacob Rombouts.

Like his father, Vermeer seems to have tried to supplement his income by art dealing. His knowledge of the art trade is shown by the fact that on 24 May 1672 he was invited to The Hague by the Elector of Brandenburg to value 12 Italian paintings. Four months after Vermeer's death, his widow, Catharina, admitted that he had been badly hit by the economic crisis that resulted from the war with France, which had begun in 1672. In a statement to the High Court about the family's insolvency, she explained: 'the works of art that he had bought and with which he was trading had to be sold at great loss in order to feed his children.' It is likely that the 26 pictures valued at only 500 guilders, which were used to meet a debt to the Delft cloth merchant, Jannetje Stevens, represented the remainder of Vermeer's dealer's stock rather than his own works. Evidence for this is their relatively low value, which also suggests that dealing constituted only a small part of his income.

The family did own The Mechelen, but the tavern was mortgaged and it did little to ease the financial burden. Vermeer's widowed mother, Digna, ran it until she was 74, only leasing it out in 1669. After her death the following year Vermeer inherited the tavern, but it brought in no additional income after the mortgage repayments were met. Even so, the Vermeers were living in Maria's house, presumably rent free, and she, having considerable wealth, may have paid a substantial proportion of the household bills. This leaves one with the suspicion that Vermeer was simply bad at handling money and was living beyond his means.

Vermeer died suddenly, probably from a stroke or a heart attack, on 13 or 14 December 1675 at the age of 43. On 15 December his body was taken to the Old Church (Fig. 9) and laid to rest in the family vault bought by Maria. The following day the Charity Commissioners noted in their records against his name 'nothing to

get', suggesting that his wife had been unable to make a donation in his name. Catharina later explained about Vermeer's tragic circumstances in a legal petition: 'Owing to the very great burden of his children, and having no means of his own, he had lapsed into such decay and decadence, which he had so taken to heart that, as if he had fallen into a frenzy, in a day or day and a half he had gone from being healthy to being dead.'

Catharina then found creditors knocking on her door demanding the repayment of debts. The first to be reimbursed was the baker, Hendrick van Buyten, who was owed 726 guilders for bread. This substantial sum would have represented about 8,000 pounds of white bread, enough to feed Vermeer's household for nearly three years. Van Buyten had already acquired one of Vermeer's paintings and he may have allowed the family to build up so large a debt because he wished to add to his collection. In January 1676 Catharina gave Van Buyten two of her husband's pictures in settlement.

In a desperate attempt to retain her favourite work, Catharina transferred ownership of *The Art of Painting* (Plate 32) to her mother. On 24 February 1676 she ceded the picture along with other rents and incomes to Maria, ostensibly to satisfy a debt. This seems to have been a ploy to prevent these assets being seized by her late husband's creditors, since just five days later an inventory was drawn up to determine which of the assets in the house belonged to Catharina and which to Maria. On 30 April 1676 Catharina petitioned the High Court to ask for permission to defer payment of some of her debts. This was granted, which meant that the Delft magistrates appointed an administrator to supervise the estate. He was Anthony van Leeuwenhoek, possibly a friend or patron of Vermeer and the scholar depicted in *The Astronomer* (Plate 36) and *The Geographer* (Plate 38).

Financial problems added to Catharina's difficulties after the death of her husband and her later life must have been tragic. Her mother, Maria, died in December 1680 at the age of 87; Catharina died at the age of 56, 12 years after Vermeer, and was buried on 2 January 1688.

After Vermeer was 'rediscovered' in the late nineteenth century, it was assumed that he had been unrecognized in his own lifetime, and overlooked as a relatively minor artist. However, contemporary evidence reveals this was not the case: three references to his fame have been found. In 1663 the French nobleman Balthasar de Monconys visited the Netherlands and recorded his impressions in his journal. On 11 August he sought out the artist, but was shocked at the price asked for his work. 'In Delft I saw the painter Vermeer who had none of his own works; but we did see one at a baker's for which six hundred livres [600 guilders] had been paid, although it contained only a single figure, for which six pistoles [60 guilders] would have been too high a price in my opinion.' The baker must have been Van Buyten, who provided the artist with bread on credit.

In 1667 Vermeer is mentioned in a book by the Dutch writer, Dirck van Bleyswijck, *Description of the Town of Delft*. In the same book, he is not only listed among eminent contemporary artists, but also features in a poem by Arnold Bon which was composed to mark the death of Fabritius, a victim of the gunpowder explosion. This poem suggests that Vermeer was regarded as Fabritius's successor, the ultimate accolade for a Delft painter:

Thus expired this Phoenix [Fabritius] to our loss
In the midst and in the best of his powers,
But happily there rose from his fire
Vermeer, who, masterlike, trod his path.

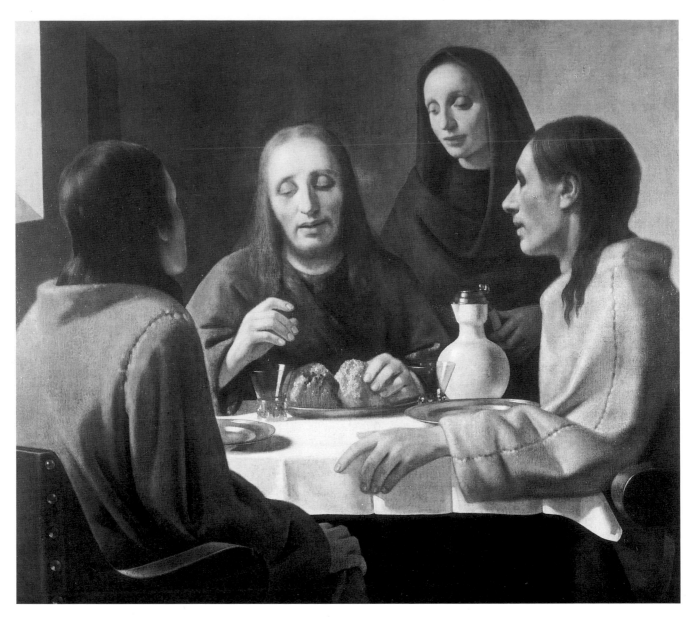

Fig. 14
HANS VAN MEEGEREN
Christ at Emmaus
*c*1936. Oil on canvas,
117 x 129 cm.
Museum Boymans-van
Beuningen, Rotterdam

A final reference to Vermeer, only noted in the Vermeer literature in 1991, is in the diary of Pieter Teding van Berkhout, a young Dutch aristocrat. In his entry for 14 May 1669 he recorded a visit to Delft: 'Upon my arrival I saw an excellent painter named Vermeer, who showed me a few curiosities made with his own hand.' On 21 June he returned to the town and again 'visited a famous painter named Vermeer who showed me some examples of his art, the most extraordinary and most curious aspect of which consists in the perspective'. It is significant that by 1669 Vermeer was already described as famous.

However, Vermeer's achievements were neglected after his death, partly because his *œuvre* was so small that he had never become well known outside his native Delft. In the eighteenth century he received scant attention in art publications, simply because few writers had seen his work. Occasionally his paintings would come up for auction, but they were often attributed to artists who were more sought after at the time, such as Rembrandt, Metsu, De Hooch and Van Mieris. It was not until over two centuries after his death that Vermeer was eventually 'rediscovered'. The French critic Théophile Thoré, who wrote under the pseudonym William Bürger, published a series of articles on the forgotten painter. Appearing in 1866 in the *Gazette des Beaux-Arts*, Thoré's writings sparked off a revival of interest and paintings, which previously were thought to be by other artists, were

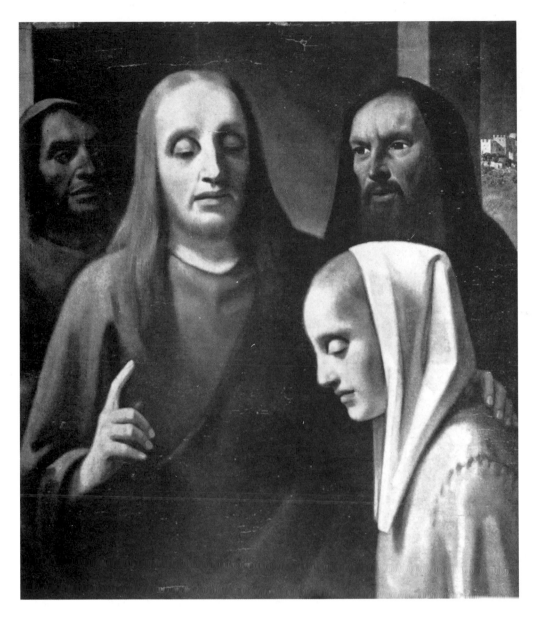

attributed to Vermeer. It then became possible to build up a picture of his *œuvre*; a task that was essentially finished by the turn of the century.

Just before the Second World War came news of a sensational series of discoveries of early Vermeers. The first, published in 1937 by the highly respected Dutch scholar Abraham Bredius, was *Christ at Emmaus* (Fig. 14), apparently of the same period as *Christ in the House of Martha and Mary* (Plate 1). The painting was bought by the Boymans Museum in Rotterdam for 550,000 guilders. Other discoveries that seemed to fill in the gaps of Vermeer's early career soon followed. *Christ and the Woman Taken in Adultery* (Fig. 15) was bought by the Nazi propaganda chief Hermann Goering in 1942. The following year the Dutch state paid 1,300,000 guilders for *Mary Magdalene Washing Christ's Feet*, for the Rijksmuseum in Amsterdam.

All these 'Vermeers' turned out to be fakes. This sensational revelation only emerged after the war when the Dutch artist Hans van Meegeren (1889–1947) was charged with collaborating with the Nazis because he had allowed *Christ and the Woman Taken in Adultery* to be sold to Goering. His claim that it was a fake was initially met with disbelief. In order to prove his ability as a forger, Van Meegeren offered to paint another 'Vermeer', completing *Christ Among the Doctors* (also known as *Young Christ*; private collection). In the

Fig. 15
HANS VAN MEEGEREN
Christ and the Woman
Taken in Adultery
*c*1940–1. Oil on canvas,
96 x 88 cm.
Private collection

subsequent court hearings it emerged that Van Meegeren had been trying to retaliate against art critics who had denied that his own earlier paintings had any artistic value.

Little has been added to the list of Vermeer's authentic paintings since the end of the nineteenth century, leaving just 36 pictures attributed to the artist, three of which are questioned by some scholars. None of the paintings remain in Delft: 22 works are in public collections in Europe and 14 in the USA, one of which, the most recently discovered Vermeer, *St Praxedis* (Plate 2), is the only one of his works owned privately. Although the chances of many further works being identified are now low, our knowledge of the artist's life has been considerably widened, thanks largely to the research of Albert Blankert, Wheelock and Montias.

Vermeer's pictures have a timeless quality. More than three centuries after his death, their mixture of tranquility and tension remains as potent as when they were painted. Despite some allusions and references which would have been apparent to an educated Delft citizen in the Golden Age, but which elude the contemporary viewer, his work is still eminently accessible. The artist's skill at depicting the intrigues of human relationships means that his work is very much appreciated today. We still marvel at Vermeer's mysterious women who are deeply engrossed in writing letters, playing music, drinking wine, or simply awaiting the arrival of their lover.

Outline Biography

1632 Johannes (Joannis or Jan) Vermeer born in Delft and baptized soon afterwards, on 31 October, in the New Church. The family live in The Flying Fox, Voldersgracht.

1641 Vermeer's father buys The Mechelen tavern in the Market Square on 23 April.

c1646–7 Begins apprenticeship (until c1652–3).

1652 Burial of Vermeer's father, Reynier Jansz Vos (b.Delft, 1591), on 12 October.

1653 On 4 April the Delft painter Leonaert Bramer intercedes on behalf of Vermeer to obtain permission from Maria Thins for him to marry her daughter, Catharina Bolnes (b.Gouda, 1631). The marriage takes place on 20 April at Schipluy. Vermeer cosigns a document with the painter Gerard ter Borch two days later. On 29 December Vermeer is admitted to the Guild of St Luke as a master painter.

c1654 Birth of the Vermeers' first child, Maria. They were to have at least ten more children.

c1654–5 Vermeer's earliest surviving painting, *Christ in the House of Martha and Mary* (Plate 1).

1655 First dated painting, *St Praxedis* (Plate 2).

1656 Second dated painting, *The Procuress* (Plate 4).

1657 On 30 November Vermeer's future patron, Pieter van Ruijven, lends the artist 200 guilders.

1660 Vermeer and his family live in the home of his mother-in-law, Maria Thins, in Oude Langendijck.

1662 In the late autumn, Vermeer is elected as an official of the Guild of St Luke (until 1664).

1663 On 11 August Balthasar de Monconys records a visit to Vermeer in his journal.

1667 Dirck van Bleyswijck lists Vermeer as a painter in his *Description of the Town of Delft*, and reproduces a poem by Arnold Bon that extols Vermeer.

1668 Third dated painting, *The Astronomer* (Plate 36).

1669 Fourth dated painting, *The Geographer* (Plate 38).

1669 Pieter Teding van Berkhout records in his journal two visits to Delft during which he met Vermeer, on 14 May and 21 June, when he refers to him as 'a famous painter'.

1670 Burial of Vermeer's mother, Digna Baltens (b.Antwerp, 1595), on 13 February; Vermeer inherits The Mechelen which he continues to rent out. Vermeer's sister, Gertruy (b.Delft, 1620), is buried on 2 May. In October Vermeer is elected for a second term as an official of the Guild of St Luke (until 1672).

1672 On 24 May Vermeer goes to The Hague to value 12 Italian paintings for the Elector of Brandenburg.

1674 Death of Vermeer's patron, Pieter van Ruijven (b.1624), on 7 August.

1675 On 20 July Vermeer travels to Amsterdam to borrow 1,000 guilders from the merchant, Jacob Rombouts. Vermeer dies on 13 or 14 December at the age of 43 and is buried on 15 December in the Old Church in Delft (Catharina is buried on 2 January 1688).

Select Bibliography

P T A Swillens, *Johannes Vermeer: Painter of Delft 1632–75*, Utrecht, 1950

Ludwig Goldscheider, *Jan Vermeer: The Paintings*, revised edition, London, 1958

Christopher Wright, *Vermeer*, London, 1976

Albert Blankert, *Vermeer of Delft: Complete Edition of the Paintings*, London, 1978

Leonard J Slatkes, *Vermeer and his Contemporaries*, New York, 1981

Arthur K Wheelock, *Jan Vermeer*, London, 1981; concise and revised edition, London, 1988

Albert Blankert, John Michael Montias, and Gilles Aillaud, *Vermeer*, New York, 1988

John Michael Montias, *Vermeer and his Milieu: A Web of Social History*, Princeton, 1989

John Nash, *Vermeer*, London, 1991

Daniel Arasse, *Vermeer: Faith in Painting*, Princeton, 1994

Norbert Schneider, *Jan Vermeer 1632–1675: Veiled Emotions*, Cologne, 1994

Edward Snow, *A Study of Vermeer*, revised edition, Berkeley, 1994

Jørgen Wadum, *Vermeer Illuminated*, The Hague, 1994

Arthur K Wheelock, *Vermeer and the Art of Painting*, New Haven and London, 1995

Ben Broos and Arthur K Wheelock (ed.), *Johannes Vermeer*, exhibition catalogue, National Gallery of Art, Washington, DC and Mauritshuis, The Hague, 1995

Christopher Wright, *The Complete Vermeer*, London, 1995

Donald Haks and Marie van der Sman (eds), *Dutch Society in the Age of Vermeer*, The Hague, 1996

Ton Brandenbarg and others, *The Scholarly World of Vermeer*, The Hague, 1996

Michiel Kersten and Daniëlle Lokin, *Delft Masters: Vermeer's Contemporaries*, Delft, 1996

Michel van Maarseveen, *Vermeer of Delft: His Life and Times*, Delft, 1996

Christiane Hertel, *Vermeer: Reception and Interpretation*, Cambridge, 1996

Lawrence Gowring, *Vermeer*, revised edition, London, 1997

List of Illustrations

Colour Plates

1 Christ in the House of Martha and
 Mary
 *c*1654–5. Oil on canvas, 160 x 142 cm.
 National Gallery of Scotland, Edinburgh

2 St Praxedis
 1655. Oil on canvas, 102 x 83 cm.
 Barbara Piasecka Johnson Collection, Princeton,
 NJ

3 Diana and her Companions
 *c*1655–6. Oil on canvas, 99 x 105 cm.
 Mauritshuis, The Hague

4 The Procuress
 1656. Oil on canvas, 143 x 130 cm.
 Gemäldegalerie Alte Meister, Staatliche
 Kunstsammlungen, Dresden

5 The Procuress
 (detail of Plate 4)

6 A Girl Asleep
 *c*1657. Oil on canvas, 00 x 77 cm.
 Metropolitan Museum of Art, New York

7 Girl Reading a Letter at an Open
 Window
 *c*1657. Oil on canvas, 83 x 65 cm.
 Gemäldegalerie Alte Meister, Staatliche
 Kunstsammlungen, Dresden

8 The Little Street
 *c*1657–8. Oil on canvas, 54 x 44 cm.
 Rijksmuseum, Amsterdam

9 The Little Street
 (detail of Plate 8)

10 Officer and Laughing Girl
 *c*1658. Oil on canvas, 51 x 46 cm.
 Frick Collection, New York

11 The Milkmaid
 *c*1658–60. Oil on canvas, 46 x 41 cm.
 Rijksmuseum, Amsterdam

12 The Milkmaid
 (detail of Plate 11)

13 The Glass of Wine
 *c*1658–60. Oil on canvas, 65 x 77 cm.
 Gemäldegalerie, Staatliche Museen zu Berlin –
 Preussischer Kulturbesitz, Berlin

14 The Girl with Two Men
 *c*1659–60. Oil on canvas, 78 x 67 cm.
 Herzog Anton Ulrich-Museum, Brunswick

15 View of Delft
 *c*1660–1. Oil on canvas, 97 x 116 cm.
 Mauritshuis, The Hague

16 View of Delft
 (detail of Plate 15)

17 Girl Interrupted at her Music
 *c*1660–1. Oil on canvas, 39 x 44 cm.
 Frick Collection, New York

18 Woman in Blue Reading a Letter
 *c*1662–4. Oil on canvas, 47 x 39 cm.
 Rijksmuseum, Amsterdam

19 The Music Lesson
 *c*1662–5. Oil on canvas, 73 x 65 cm.
 Royal Collection

20 The Music Lesson
 (detail of Plate 19)

21 Woman Holding a Balance
 *c*1664. Oil on canvas, 40 x 36 cm.
 National Gallery of Art, Washington, DC

22 Woman Holding a Balance
 (detail of Plate 21)

23 Woman with a Pearl Necklace
 *c*1664. Oil on canvas, 55 x 45 cm.
 Gemäldegalerie, Staatliche Museen zu Berlin –
 Preussischer Kulturbesitz, Berlin

24 Woman with a Lute
 *c*1664. Oil on canvas, 51 x 46 cm.
 Metropolitan Museum of Art, New York

25 Young Woman with a Jug
 c1664–5. Oil on canvas, 46 x 41 cm.
 Metropolitan Museum of Art, New York

26 The Girl with the Pearl Earring
 c1665. Oil on canvas, 45 x 39 cm.
 Mauritshuis, The Hague

27 A Lady Writing
 c1665. Oil on canvas, 45 x 40 cm.
 National Gallery of Art, Washington, DC

28 A Lady Writing
 (detail of Plate 27)

29 Girl with a Red Hat
 c1665. Oil on panel, 23 x 18 cm.
 National Gallery of Art, Washington, DC

30 Girl with a Flute (circle of Vermeer)
 c1665. Oil on panel, 20 x 18 cm.
 National Gallery of Art, Washington, DC

31 The Concert
 c1665–6. Oil on canvas, 73 x 65 cm.
 Isabella Stewart Gardner Museum, Boston, MA
 (stolen 1990)

32 The Art of Painting
 c1666–7. Oil on canvas, 120 x 100 cm.
 Kunsthistorisches Museum, Vienna

33 The Art of Painting
 (detail of Plate 32)

34 Head of a Young Woman
 c1666–7. Oil on canvas, 45 x 40 cm.
 Metropolitan Museum of Art, New York

35 Mistress and Maid
 c1667–8. Oil on canvas, 92 x 79 cm.
 Frick Collection, New York

36 The Astronomer
 1668. Oil on canvas, 50 x 45 cm.
 Musée du Louvre, Paris

37 The Astronomer
 (detail of Plate 36)

38 The Geographer
 c1668–9. Oil on canvas, 53 x 47 cm.
 Städelsches Kunstinstitut und Städtische Galerie,
 Frankfurt

39 The Love Letter
 c1669–70. Oil on canvas, 44 x 39 cm.
 Rijksmuseum, Amsterdam

40 The Love Letter
 (detail of Plate 39)

41 The Lacemaker
 c1669–70. Oil on canvas, 25 x 21 cm.
 Musée du Louvre, Paris

42 The Lacemaker
 (detail of Plate 41)

43 Lady Writing a Letter with her Maid
 c1670. Oil on canvas, 71 x 58 cm.
 National Gallery of Ireland, Dublin

44 Allegory of Faith
 c1671–4. Oil on canvas, 114 x 89 cm.
 Metropolitan Museum of Art, New York

45 The Guitar Player
 c1672. Oil on canvas, 53 x 46 cm.
 Iveagh Bequest, Kenwood, London

46 A Lady Standing at the Virginal
 c1673–5. Oil on canvas, 52 x 45 cm.
 National Gallery, London

47 A Lady Standing at the Virginal
 (detail of Plate 46)

48 A Lady Seated at the Virginal
 c1673–5. Oil on canvas, 52 x 46 cm.
 National Gallery, London

Text Illustrations

1 L SCHENK
The Mechelen (detail of View of
Market Place)
*c*1720. Engraving after drawing by Abraham
Rademaecker

2 JAN STEEN
Inn with Violinist and Card Players
*c*1665–8. Oil on canvas, 82 x 69 cm.
Royal Collection

3 LEONAERT BRAMER
The Fortune Teller
(after Jan Lievens)
*c*1652. Black chalk on paper, 40.5 x 30.6 cm.
Kupferstichkabinett, Staatliche Museen zu
Berlin – Preussischer Kulturbesitz, Berlin

4 WILLEM BLAEU
Map of Delft (detail)
1649. Engraving.
From *City Atlas of the Netherlands* (Amsterdam,
1649)

5 CAREL FABRITIUS
View of Delft
1652. Oil on canvas, 15 x 32 cm.
National Gallery, London

6 ABRAHAM RADEMAECKER
The Jesuit Church
Early eighteenth century.
Pen and ink on paper, 16 x 23 cm.
Gemeente Archief, Delft

7 EGBERT VAN DER POEL
View of Delft after the Explosion
*c*1654–5. Oil on panel, 36 x 50 cm.
National Gallery, London

8 GERARD HOUCKGEEST
Interior of the New Church in Delft
1651. Oil on panel, 78 x 66 cm.
Mauritshuis, The Hague

9 EMANUEL DE WITTE
Interior of the Old Church in Delft
1651. Oil on panel, 61 x 44 cm.
Wallace Collection, London

10 JAN STEEN
The Burgher of Delft and his
Daughter
1655. Oil on canvas, 82 x 69 cm.
Private collection

11 JAN VAN DER HEYDEN
Old Church in Delft
*c*1700. Oil on panel, 55 x 71 cm.
Detroit Institute of Arts, Detroit, MI

12 Probable self-portrait of Vermeer
(detail of Plate 4)

13 Probable self-portrait of Vermeer
(detail of Plate 32)

14 HANS VAN MEEGEREN
Christ at Emmaus
*c*1936. Oil on canvas, 117 x 129 cm.
Museum Boymans-van Beuningen, Rotterdam

15 HANS VAN MEEGEREN
Christ and the Woman Taken in Adultery
*c*1940–1. Oil on canvas, 98 x 88 cm.
Private collection

Comparative Figures

16 ERASMUS QUELLINUS
Christ in the House of Martha and
Mary
*c*1650. Oil on canvas, 172 x 243 cm.
Musée des Beaux-Arts, Valenciennes

17 FELICE FICHERELLI
St Praxedis
*c*1640–5. Oil on canvas, 104 x 81 cm.
Fergnani Collection, Ferrara

18 JACOB VAN LOO
Diana and her Companions
1648. Oil on canvas, 134 x 167 cm.
Bodemuseum, Staatliche Museen zu Berlin –
Preussischer Kulturbesitz, Berlin

19 FRANS VAN MIERIS
The Charlatan
*c*1650–5. Oil on panel, 49 x 38 cm.
Galleria degli Uffizi, Florence

20 NICOLAES MAES
A Sleeping Maid (detail)
1655. Oil on panel.
National Gallery, London

21 PIETER DE HOOCH
Courtyard of a House in Delft
1658. Oil on canvas, 74 x 60 cm.
National Gallery, London

22 PIETER DE HOOCH
An Interior with a Woman Drinking
with Two Men
*c*1658. Oil on canvas, 74 x 65 cm.
National Gallery, London

23 GERARD DOU
The Dutch Cook
*c*1640. Oil on panel, 36 x 27 cm.
Musée du Louvre, Paris

24 ABRAHAM RADEMAECKER
View of Delft with Schiedam and
Rotterdam Gates
Early eighteenth century.
Pen and ink on paper, 23 x 45 cm.
Stedelijk Museum, Delft

25 GABRIEL METSU
Man and a Woman Seated by a
Virginal
*c*1665. Oil on panel, 38 x 32 cm.
National Gallery, London

26 FRANS VAN MIERIS
The Duet
1658. Oil on panel, 32 x 25 cm.
Staatliches Museum, Schwerin

27 PIETER DE HOOCH
Woman Weighing Gold
*c*1664. Oil on canvas, 61 x 53 cm.
Gemäldegalerie, Staatliche Museen zu Berlin –
Preussischer Kulturbesitz, Berlin

28 HUYCK ALLART
Map of the Seventeen Provinces of
the Netherlands
1671. Engraving.
Bibliotheek der Rijksuniversiteit, Leiden

29 GERARD TER BORCH
Woman Writing a Letter
*c*1655. Oil on panel, 39 x 30 cm.
Mauritshuis, The Hague

30 DIRCK VAN BABUREN
The Procuress
1622. Oil on canvas, 101 x 107 cm.
Museum of Fine Arts, Boston, MA

31 LOUIS GARREAU
The Astronomer (after Vermeer)
1784. Engraving, 19 x 17 cm.

32 JODOCUS HONDIUS
Celestial Globe
1600. 34 cm in diameter.
Nederlands Scheepvaartmuseum, Amsterdam

33 JAN VERKOLJE
Portrait of Anthony van Leeuwenhoek
*c*1680–90. Oil on canvas, 56 x 48 cm.
Rijksmuseum, Amsterdam

34 GABRIEL METSU
Woman Reading a Letter
*c*1663. Oil on canvas, 52 x 41 cm.
National Gallery of Ireland, Dublin

35 JACOB JORDAENS
Crucifixion
Early 1620s. Oil on canvas, 310 x 197 cm.
Terningh Foundation, Antwerp

36 OTTO VAN VEEN
Cupid (Perfectus Amor Est Nisi ad Unum)
1608. Engraving.
From *Amorum Emblemata* (Antwerp, 1608)

37 GERARD DOU
Woman Playing the Virginal
*c*1665. Oil on canvas, 37 x 28 cm.
Dulwich Picture Gallery, London

Christ in the House of Martha and Mary

*c*1654–5. Oil on canvas, 160 x 142 cm. National Gallery of Scotland, Edinburgh

This is Vermeer's earliest known painting, which depicts the biblical scene of Jesus visiting the sisters Martha and Mary. As told in Luke 10, Martha complained that Mary was neglecting her work, sitting beside Christ and listening to his words, instead of serving food. Jesus replied: 'Mary hath chosen that good part, which shall not be taken away from her.' Vermeer interprets the sisters as representing two temperaments, the active and the contemplative. This theme may have had a personal meaning for the artist, who, raised in a busy tavern in which his mother and elder sister must have served, may have believed that he was marked out for a more reflective life.

'Christ in the House of Martha and Mary' was a popular subject among Flemish artists. Vermeer is likely to have been inspired by a version completed several years earlier by the Antwerp artist Erasmus Quellinus (1607–78) (Fig. 16). Similarities between the two versions are evident in the figures of Christ and in the folds of his drapery. Stylistically, Vermeer's picture was also influenced by the Utrecht School, a group of artists who used the dramatic lighting effects of the Italian painter Caravaggio (1571–1610).

Vermeer's distinctive treatment of the subject is characterized by the intimate way that he focuses on the triangular relationship of the three figures. This is emphasized by the relative positions of the characters to one another: Christ looks at Martha, while pointing to Mary, who is looking up at him. Vermeer has only sketched in the background of the modestly furnished room, so that the viewer's attention is focused on the figures.

Fig. 16
ERASMUS QUELLINUS
Christ in the House
of Martha and Mary
*c*1650. Oil on canvas,
172 x 243 cm.
Musée des Beaux-Arts,
Valenciennes

St Praxedis

1655. Oil on canvas, 102 x 83 cm. Barbara Piasecka Johnson Collection, Princeton, NJ

Fig. 17
Felice Ficherelli
St Praxedis
*c*1640–5. Oil on canvas,
104 x 81 cm.
Fergnani Collection,
Ferrara

This is the most recently discovered Vermeer, first attributed to him in 1969, after the discovery of two of his signatures on the work (it is unclear why it was signed twice). Although it has been accepted by most scholars, some still remain sceptical about the attribution. The work is a copy of a painting of St Praxedis by the Florentine artist Felice Ficherelli (Fig. 17).

St Praxedis was a second-century Roman virgin who was honoured for having cared for the bodies of Christian martyrs. The kneeling figure of the saint is depicted wringing blood from a sponge into a ewer as she tends to the body of a martyr, beside which lies a horrific severed head. In the background, to the right, is a small female figure walking towards a classical building, who is probably her sister St Pudentiana.

The main difference between Ficherelli's original and Vermeer's copy is the addition of the golden crucifix in the saint's hands. Vermeer's version is dated 1655, two years after his marriage to Catharina and his conversion to Catholicism. St Praxedis was a popular subject among Jesuits and the addition of the crucifix is another indication that it was painted by a Catholic.

It remains a mystery where Vermeer saw the original painting, which dates from *c*1640–5. There is no evidence that he ever visited Italy, but he may have seen the picture (or another version of it) with a dealer or collector in a Dutch city such as Amsterdam. Vermeer's version emphasizes the pensive face of the saint, with the downward-looking eyes that were to appear in so many of his later pictures. There are also similarities between the inclination of the saint's head and that of the figure in *A Girl Asleep* (Plate 6).

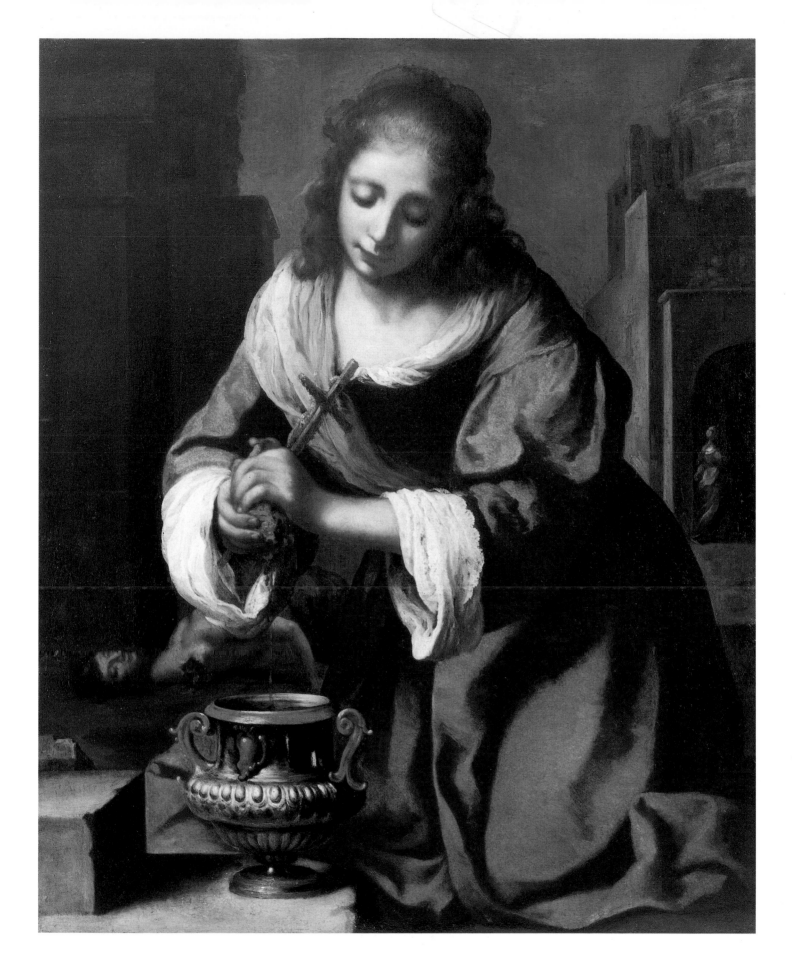

3 Diana and her Companions

c1655–6. Oil on canvas, 99 x 105 cm. Mauritshuis, The Hague

Vermeer's only surviving mythological picture depicts Diana, the goddess of hunting and the moon. As dusk falls, Diana, wearing a crescent moon on her head, rests after the hunt. A nymph bends over washing the goddess's feet while two other nymphs look on; a fourth, her shoulder bare, turns away.

The painting depicts a scene just before the climax of the story recorded in Ovid's *Metamorphoses*. Diana is washing herself when Actaeon, a young prince out hunting, inadvertently discovers the group. Diana is surrounded by her nymphs as they try to hide her nakedness, but the unintentional voyeur meets his fate when the goddess splashes him with water, transforming him into a stag which is devoured by his own hounds. In Vermeer's painting, it is possible that the thistle, a symbol of masculinity, could be a reference to Actaeon's impending arrival.

Vermeer may have been inspired by a work by the Amsterdam painter Jacob van Loo (1614–70), dating from seven years earlier (Fig. 18). Van Loo depicted almost the same stage of the story and the poses of some of the figures are similar. What is striking about Vermeer's version is the eloquent way in which he captures the tranquil moment before the intrusion of Actaeon, by concealing or shading the eyes of the women, suggesting their repose.

Fig. 18
JACOB VAN LOO
Diana and her
Companions
1648. Oil on canvas,
134 x 167 cm.
Bodemuseum, Staatliche
Museen zu Berlin –
Preussischer Kulturbesitz,
Berlin

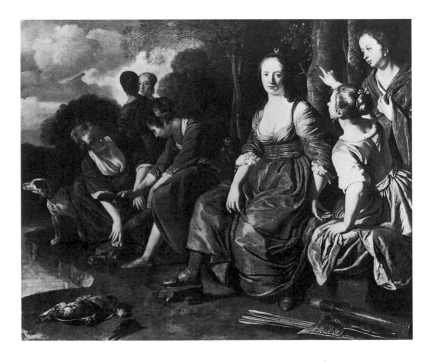

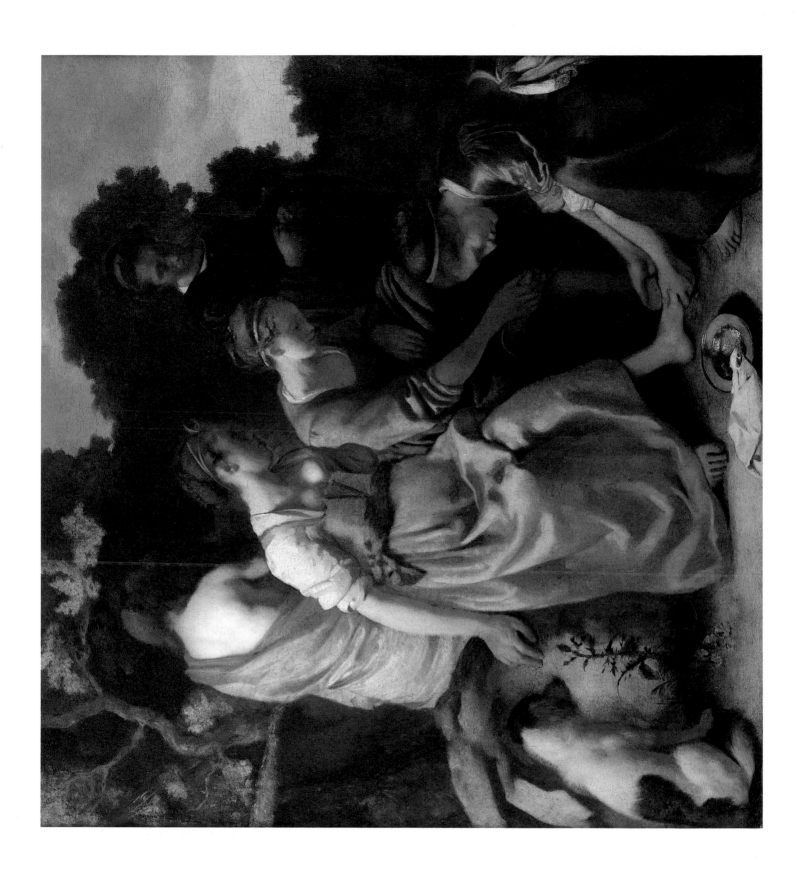

The Procuress

1656. Oil on canvas, 143 x 130 cm. Gemäldegalerie Alte Meister, Staatliche. Kunstsammlungen, Dresden

Fig. 19
FRANS VAN MIERIS
The Charlatan
c1650–5. Oil on panel,
49 x 38 cm.
Galleria degli Uffizi, Florence

The Dutch popularized a type of painting known as a *bordeeltgen*. This was a brothel picture, usually with a moralizing element that made it perfectly suitable to hang in a family home. Indeed, Vermeer's inspiration, more in terms of subject-matter than composition, may have been a painting owned by his mother-in-law, Maria Thins, *The Procuress* by Dirck van Baburen (Fig. 30).

Vermeer's scene is composed around the figures of the young woman and the soldier, whose brightly coloured clothing ensures that they hold centre stage. Clasping a large wineglass, the woman puts out her hand to receive the gold coin offered by the soldier, who clutches her breast with his left hand. The sinister dark figure next to the soldier is 'the procurer', who is probably a woman although the features are androgynous. Beside the procuress is a grinning figure raising a glass and holding a cittern. He is elegantly dressed in Burgundian clothing, a slitted jacket and a black velvet beret. This young man is probably a self-portrait of the artist, who was about 23 at the time (since the picture is dated 1656). His position at the edge of the composition is similar to that of a self-portrait included in *The Charlatan* by Frans van Mieris, dating from a few years earlier (Fig. 19). Both Van Mieris and Vermeer depict themselves with an open mouth, long hair, a black beret and a lace collar. The expression of the grinning face in Vermeer's painting also has some similarities with the face in Rembrandt's *Prodigal Son in the Tavern*, of c1636 (Gemäldegalerie, Dresden), in which the artist portrayed his own features.

The Procuress is probably set in a tavern. Viewed from below, the figures are behind what appears to be a balustrade, over which an Oriental carpet and the soldier's black cloak are draped. The picture is spatially unclear, but Vermeer probably intended there to be a table behind the balustrade, on which the pitcher of wine is meant to stand. As it is, this elegant pitcher seems precariously balanced too close to the woman's left hand; one small knock would send it crashing to the ground.

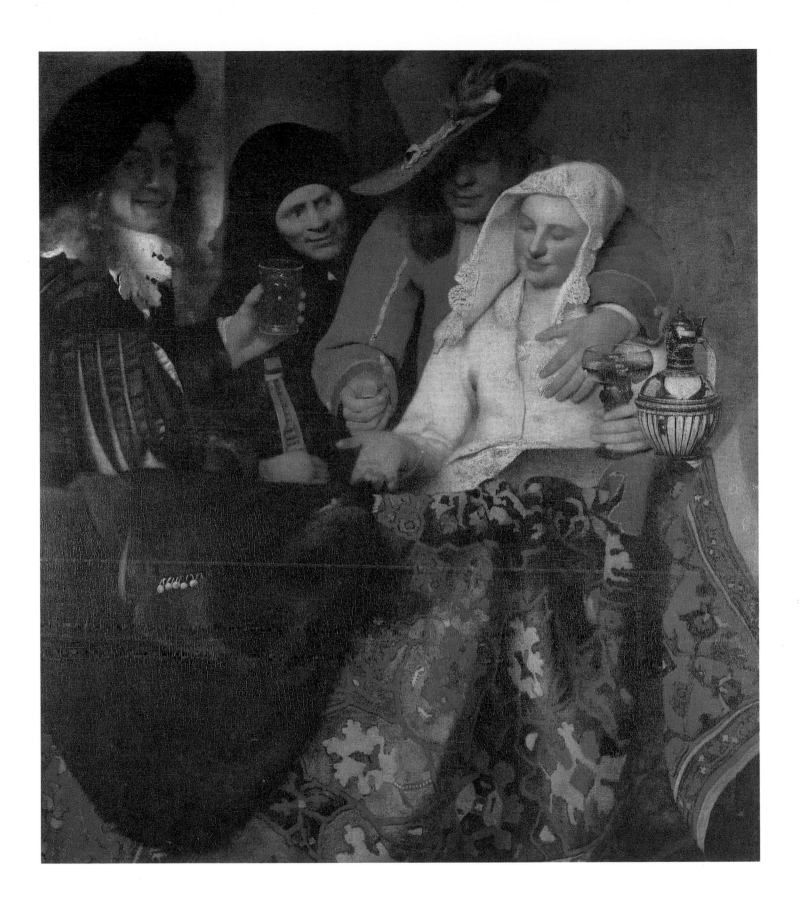

The Procuress (detail of Plate 4)

At first glance, the painting must simply be regarded as a representation of bought love, with the offering and willing acceptance of the coin; but there is also an intriguing ambiguity, which is characteristic of Vermeer's work. The curious position in which the man holds the coin suggests that he may not simply be offering it, but that he might be about to flip it into the air or playfully hide it between his thumb and finger. The young woman's head seems to nestle restfully against the man's shoulder and her expression seems to suggest contentment rather than greed. *The Procuress* represents a transitional work from Vermeer's early religious paintings to his later genre pictures.

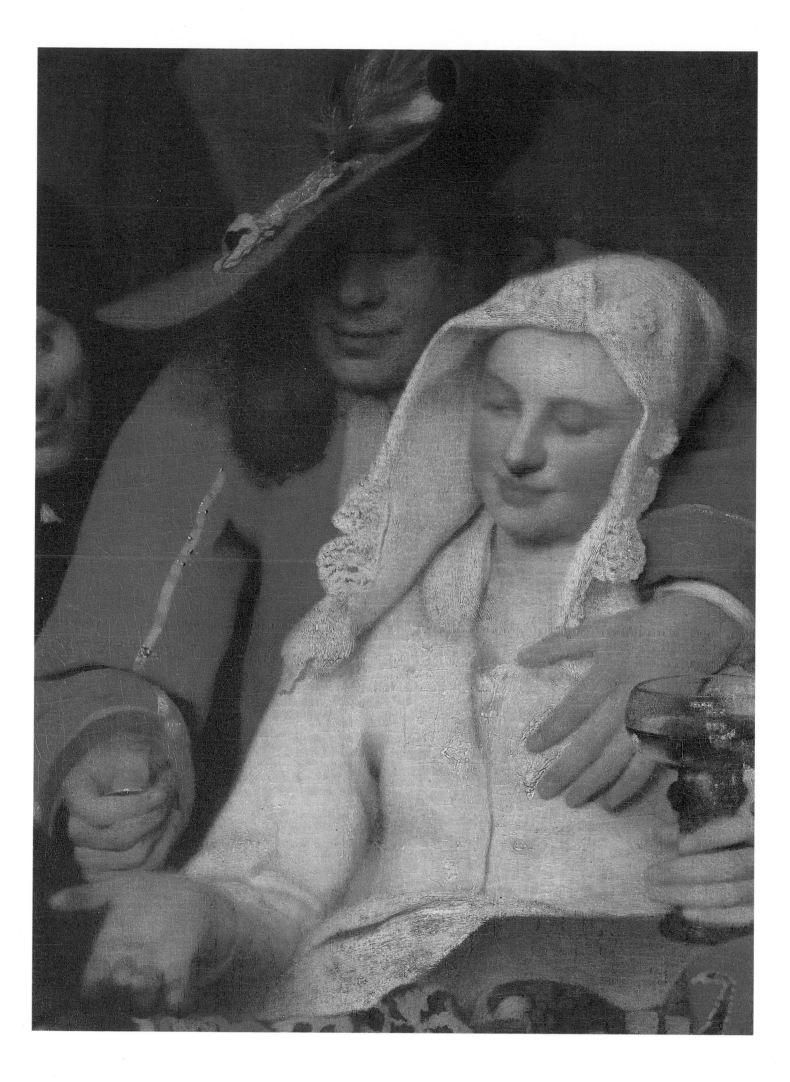

A Girl Asleep

*c*1657. Oil on canvas, 88 x 77 cm. Metropolitan Museum of Art, New York

Fig. 20
NICOLAES MAES
A Sleeping Maid (detail)
1655. Oil on panel.
National Gallery, London

The girl sits at a table with her eyes closed, resting her head on her right hand, yet it is unclear whether she is actually asleep, deep in thought or drunk. Her face suggests sleep, but the pose is that of someone deep in melancholy thought, which may have been provoked by wine. A clue to how the painting was regarded in the seventeenth century is its title in a 1696 inventory, 'A Drunken Sleeping Maid'.

The young woman is framed against a square of wall, the four sides of which are composed by the door, the edge of the table, the left side of the canvas and the bottom of the picture hanging on the wall above her. Only part of this picture is visible, showing the leg of a standing figure and a mask lying on the ground. The mask is probably a reference to deception and perhaps holds a clue to the nature of the girl's thoughts and whatever has made her drown her sorrows in drink. In front of her is an almost empty wineglass, only just visible against the patterned Oriental rug. Around the base of the white porcelain wine jug the paint surface has been damaged and the brown smudge was probably once a second wineglass which had toppled over, although it is unclear whether or not this was painted by Vermeer.

This is Vermeer's first carefully composed interior. Through the half-open door, the room beyond can be seen, neatly furnished with a table and a mirror. The orderliness of the rear room contrasts with the disarray around the girl, and her sleep may well be a warning of the disorder that accompanies sloth. An X-ray examination has revealed that Vermeer initially painted a man in the room beyond, but he was later overpainted and his head replaced by the framed mirror on the back wall. In eliminating this figure, Vermeer presumably wanted to avoid the more explicit approach of his contemporaries, such as the Dordrecht artist Nicolaes Maes (1634–93) (Fig. 20), making his painting more intriguing.

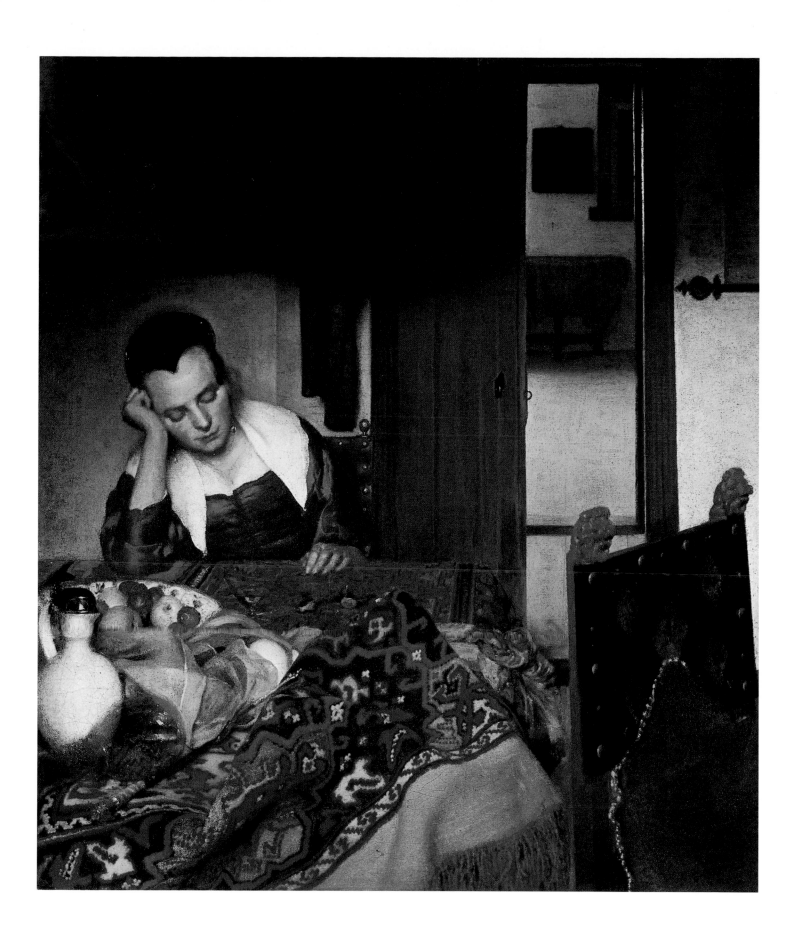

Girl Reading a Letter at an Open Window

c1657. Oil on canvas, 83 x 65 cm. Gemäldegalerie Alte Meister, Staatliche Kunstsammlungen, Dresden

This is the first of Vermeer's paintings of a young woman engrossed in reading or writing a letter. She stands in front of an open window, deep in concentration. It must be assumed that she is reading a love letter and her expression hints that its contents may not be entirely good news. The woman seems trapped in her room, an impression created by the large table in the foreground and the heavy, textured drapes, but the open window and the letter suggest a link with the outside world.

Vermeer, known as 'the painter of light', has realistically captured the effect of sunlight streaming through the window onto the wall, using tones that range from very dark in the shadows, to bright in the patch of light behind the girl's back. The artist has also succeeded in rendering light falling on objects, such as the Oriental rug, the toppling bowl of fruit, the letter and the girl's curly hair. He has evoked the rich texture of the girl's jacket with accents of yellow paint, applied in a pointillist technique.

X-rays reveal that Vermeer altered his composition. Originally the girl's face was turned slightly away from the viewer, which helps to explain the angle of the more full-faced reflection in the window. The room was more cluttered, with a large wineglass on the table at the far right where a green curtain now hangs. At first glance this curtain looks as if it is inside the room, however it does not quite reach the bottom of the picture, which suggests that it is a *trompe l'œil* image of a dust curtain, giving the illusion that it could be drawn across the painting to protect it. This device had been used earlier by both Gerard Dou in a self-portrait of c1645 (Rijksmuseum, Amsterdam) and Rembrandt in his *Holy Family* of 1646 (Gemäldegalerie, Kassel). Vermeer, however, has left it ambiguous as to whether the curtain is inside or outside the room. The rod of a *trompe l'œil* dust curtain would normally be shown casting a shadow on the painting, which is absent here, and the fall of the light coming from the left suggests that the curtain is illuminated by sunlight from the window.

In 1742 the Elector of Saxony, August III, acquired this painting, which he believed to be a Rembrandt; the previous year he had bought *The Procuress* (Plate 4). During the Second World War both pictures were among Dresden's works of art hidden for safety and consequently spared from the British bombing. In 1945 they were seized by the Red Army as booty and secretly taken to Moscow. When the question of returning Dresden's pictures arose, the Soviet minister of culture wanted East Germany to allow two works to remain in Russia in gratitude. His choice, a masterpiece by Giorgione (c1476/8–1510) and *Girl Reading a Letter at an Open Window*, is evidence of the importance of this early Vermeer. This proposal was dropped and both Vermeers were among the paintings returned to Dresden in 1955.

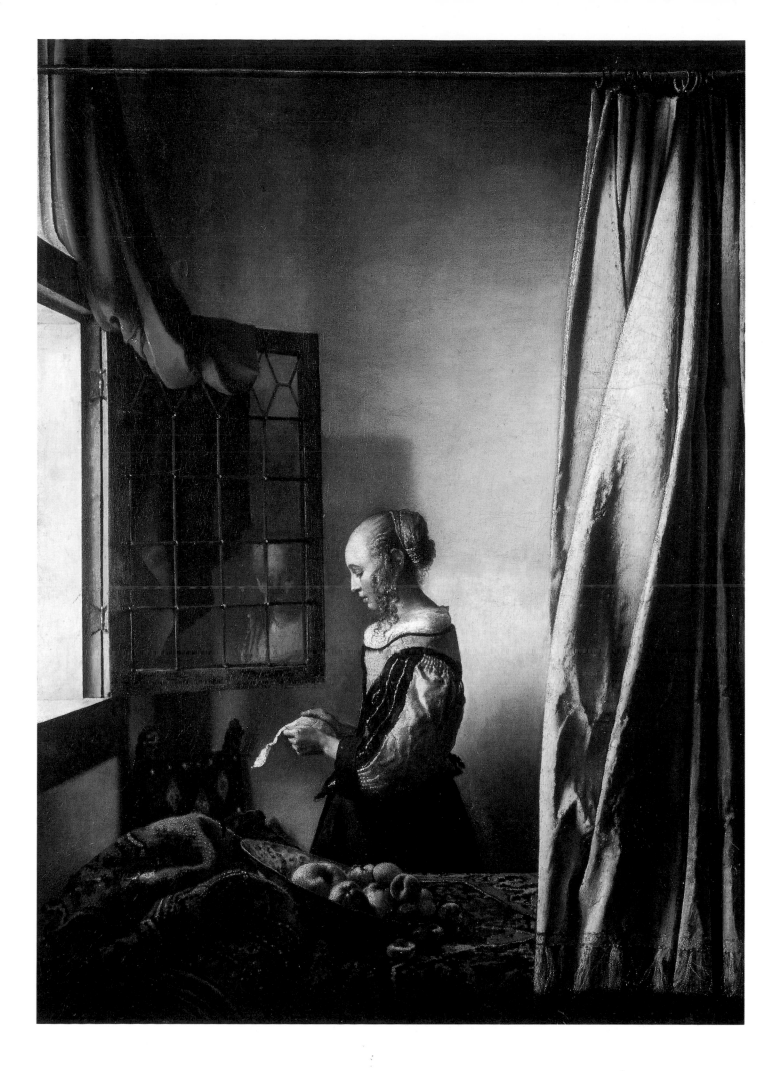

The Little Street

c1657–8. Oil on canvas, 54 x 44 cm. Rijksmuseum, Amsterdam

Fig. 21
PIETER DE HOOCH
Courtyard of a House
in Delft
1658. Oil on canvas,
74 x 60 cm.
National Gallery, London

This is Vermeer's only surviving street scene of Delft, lovingly depicted by an artist who had spent nearly all his life in the town. It shows a view which appears to have been framed arbitrarily, as if it was seen through a window. Most of the larger house on the right is shown, except for the tip of the gable and the right-hand side, but only half of the smaller house on the left is depicted and it is partly obscured by creeper (the green paint of the leaves has turned slightly blue, a deterioration which has occurred on other Vermeer paintings). Although the cloudy sky suggests movement, the small figures seem frozen in time, engrossed in their own worlds.

For many years this painting was believed to portray the view from the back of The Mechelen, showing the houses on the other side of the street named Voldersgracht. But a detailed examination of the configuration of the houses on contemporary maps reveals this could not have been the case and no other site in Delft has been identified. It is quite possible that Vermeer did not depict an actual place, but an imaginary view which incorporated various elements of the architecture of Delft; in either case, his painting gives a realistic and evocative impression of the back streets which lay close to the Market Square.

Pieter de Hooch painted a number of similar scenes in Delft at this period. These often depicted courtyards, with views through alleyways which give a vivid impression of domestic life (Fig. 21). Wheelock dates *The Little Street* to 1657–8, which means that it may have influenced De Hooch's *Courtyard of a House in Delft*, dated 1658 (although Blankert dates the Vermeer to 1661, in which case the influence would have been the other way).

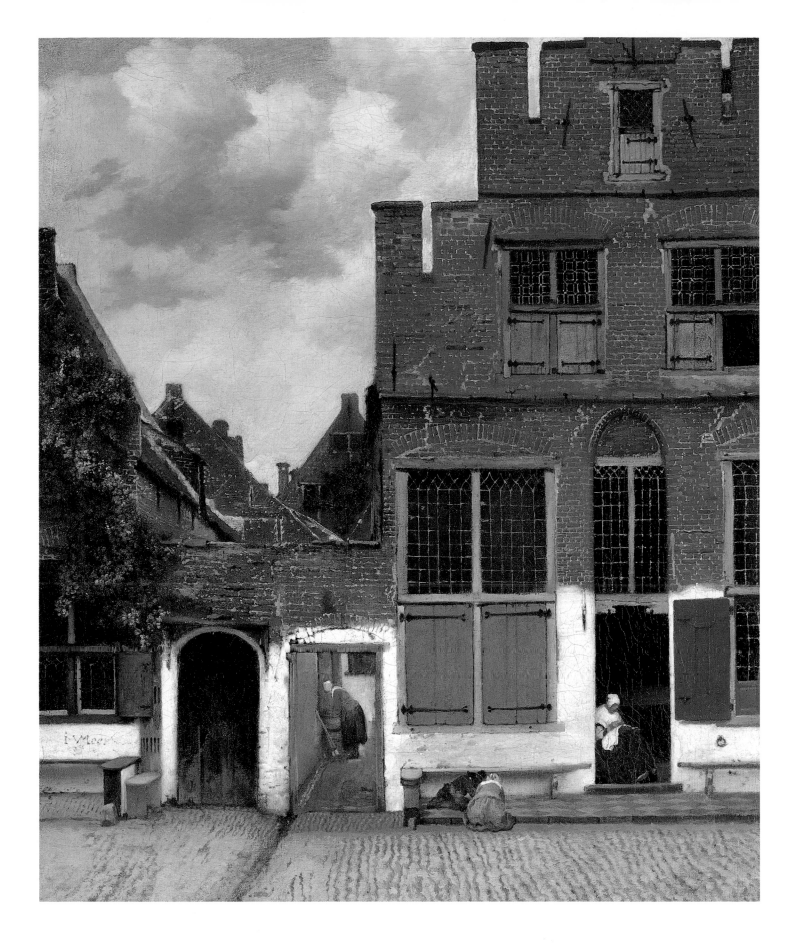

The four figures are all bending over, their faces invisible. The elderly woman sitting in the doorway is busy with her needlework or lacemaking. Although one of the shutters is open, the room beyond her is dark and all that can be discerned is a piece of furniture, perhaps a table. The maid in the courtyard is bent over what appears to be a washtub and standing beside her in readiness for use are two brooms. On the tiled pavement, a young boy and girl are engrossed in a game.

The people are painted very loosely with just a few brushstrokes, making them anonymous characters set against the distinctive building. Vermeer has captured the texture of the exterior of the house with its whitewashed lower portion, which has already become dirty, and the bricks with their patchy mortar.

*c*1658. Oil on canvas, 51 x 46 cm. Frick Collection, New York

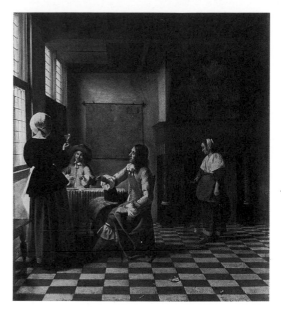

Fig. 22
PIETER DE HOOCH
An Interior with a
Woman Drinking with
Two Men
*c*1658. Oil on canvas,
74 x 65 cm.
National Gallery, London

There is a striking contrast between the outline of the officer sitting in shadow and the glowing face of the girl illuminated by the sunlight that streams through the open window. The figure of the officer looms almost disconcertingly large in comparison with the girl. This effect, exaggerated by the contrast between the young woman's tied head-scarf and the man's wide-brimmed hat, makes him appear threatening and her exposed and vulnerable. By means of this composition, Vermeer suggests that the viewer is also in the room, just behind the officer. The map depicted on the back wall represents Holland and West Friesland, with north to the right, and was drawn by Balthasar van Berckenrode and published by Willem Blaeu in the early 1620s.

The attentive girl laughingly gazes into the officer's eyes. Her right hand clutches a glass of wine and her left hand rests on the table in a relaxed fashion, her palm facing upwards; this is an ambiguous gesture that could be interpreted as a request for money. The mood of this brightly coloured painting, possibly inspired by De Hooch, is exuberant. In *An Interior with a Woman Drinking with Two Men* (Fig. 22), De Hooch also illuminates the figures from a window on the left. Vermeer's work is likely to have been painted in the same year as this picture but, as the slightly older De Hooch had been doing similar 'merry company' scenes for several years, his painting is more likely to have come first. Not surprisingly, the Vermeer was once thought to be by De Hooch and in the nineteenth century it had a fake signature, since removed, and was sold as one of his works.

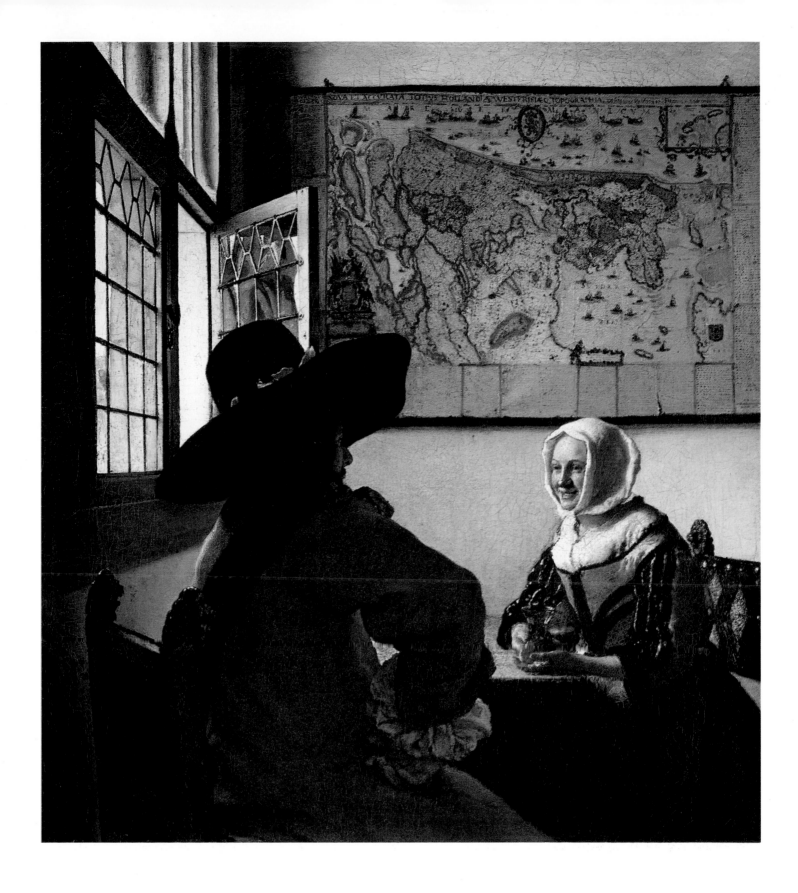

The Milkmaid

*c*1658–60. Oil on canvas, 46 x 41 cm. Rijksmuseum, Amsterdam

Fig. 23
GERARD DOU
The Dutch Cook
*c*1640. Oil on panel,
36 x 27 cm.
Musée du Louvre, Paris

Unlike most of Vermeer's paintings, which depict richly dressed people in elegant interiors, this picture shows a simple milkmaid in a kitchen. Her job was to make butter and cheese, and she pours the thick milk from an earthenware jug into a bowl. Vermeer's stream of white paint creates an uncannily realistic image of the flowing milk, which gives the impression that it will pour for eternity. Vermeer may have been influenced by Dou's *The Dutch Cook* (Fig. 23), although the same action in *The Milkmaid* is much more realistic.

Dressed in a white milkmaid's headscarf, yellow bodice, and red skirt with a blue apron tucked into her waistband, the young woman has a sturdy build and muscular arms. Her eyes are lowered in concentration as she carefully pours the milk. It has been suggested that Vermeer might have used his family's maid as his model, a woman named Tanneke Everpoel.

Aside from the brass pot and square wicker basket hanging in the corner of the room, the wall behind the woman is bare. There are two nails and several marks on the wall which have been carefully emphasized, presumably to show that it was a working kitchen, not an elegant room. Along the skirting of the floor are blue and white Delft tiles, depicting itinerant figures who bear the tools of their trade on their backs (similar tiles can be seen more clearly in *A Lady Standing at the Virginal*, Plate 46). On the floor is a foot-warmer containing a bowl for hot coals.

This has always been one of Vermeer's most popular paintings, perhaps because the milkmaid seems to represent homely virtue. When it was sold in 1719, the picture was described as 'the famous Milkmaid, by Vermeer of Delft, artful'. Later in the eighteenth century, after Vermeer had been largely forgotten, one of the few surviving references to him appears in the journal of the British artist Joshua Reynolds (1723–92), who visited the Netherlands. When writing about the paintings which had most impressed him on his 1781 trip he mentioned a work in Amsterdam which he described as 'a woman pouring milk from one vessel to another: by D Vandermeere'.

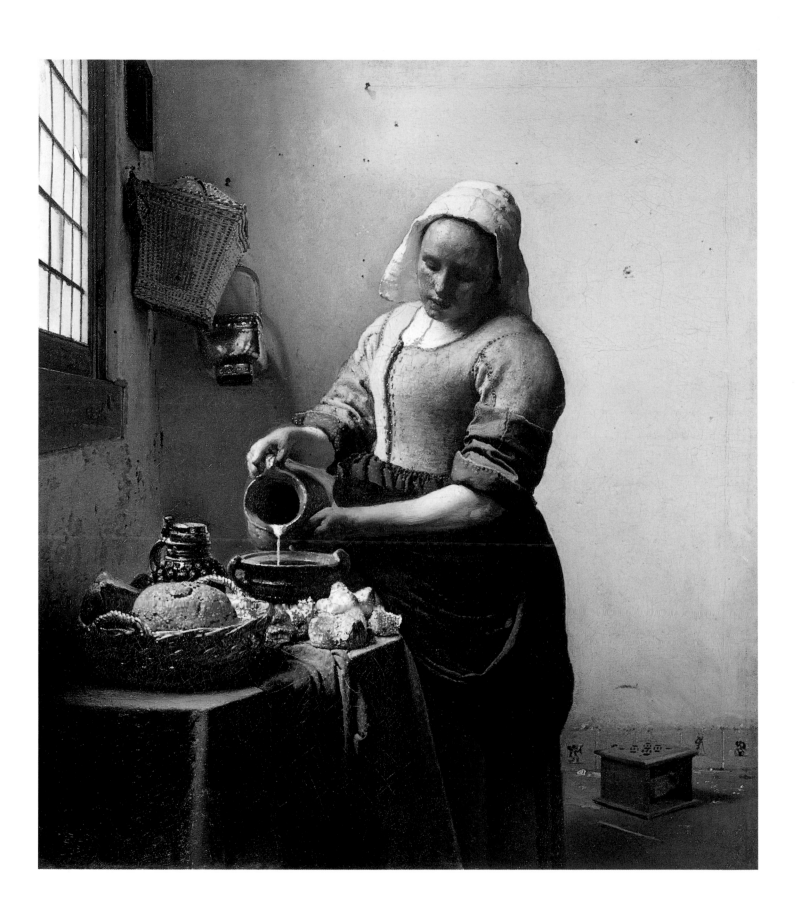

Vermeer painted a marvellous still life on the table: at the back is the two-handled earthenware bowl into which the milk is being poured, next to it are several crispy rolls, a blue tablecloth hanging in folds, a glazed pitcher and a basket of bread.

The breadbasket appears to be the same as that depicted in Vermeer's first painting, *Christ in the House of Martha and Mary* (Plate 1). But whereas in the early picture the bread looks rather flat and one-dimensional, here it appears crusty and enticing. An X-ray analysis of the paintwork reveals that the bread was painted in three layers. The lower one is a thick coat of lead white, over which Vermeer painted a thin reddish glaze through which particles of the original white protrude. On top of this the artist added highlights of whitish-yellow paint.

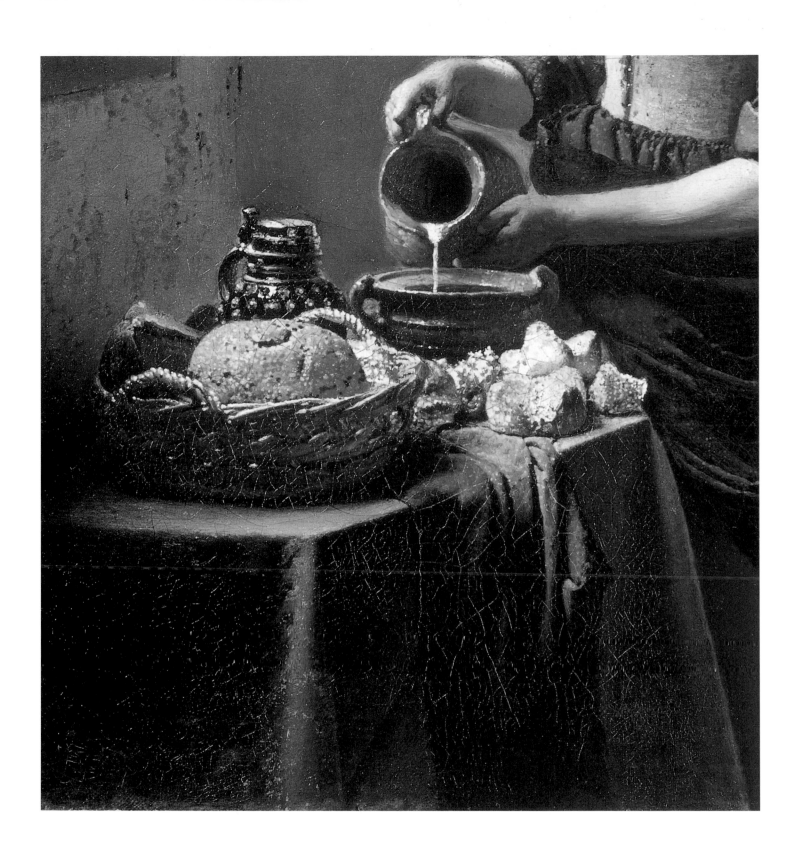

13 The Glass of Wine

c1658–60. Oil on canvas, 65 x 77 cm. Gemäldegalerie, Staatliche Museen zu Berlin –
Preussischer Kulturbesitz, Berlin

The head of the woman is almost hidden by her white headscarf and
the nearly empty wineglass raised to her lips. She is elegantly clothed
in an ornate silk dress, edged with gold. The man, looking straight
towards her, holds a white porcelain pitcher in his right hand, with
which he is presumably about to refill her glass. Vermeer's picture is
clearly indebted to the interiors of De Hooch, such as *Woman Drinking
with Soldiers* of 1658 (Musée du Louvre, Paris).

The two figures are at a table covered with an Oriental rug, on which
lie several books and some music. On the chair is a blue cushion, an
item of clothing (possibly the man's sash) and a cittern, which the
woman has probably just laid aside. The painting in the gilded frame
at the back of the room, no longer clearly visible, is a landscape in the
style of the Dutch artist Allaert van Everdingen (1621–75).

The window at the far end of the room is shuttered, but one of the
closer pair is slightly ajar. It is a leaded window with a stained-glass
design in the centre depicting a circular coat of arms over the figure of
a standing woman. She holds what appears to be a pair of horse's reins
in her right hand, which suggests that she represents the personi-
fication of Temperance. The coat of arms have been identified as
those of Janetge Vogel, who lived in a house on the Oude Delft canal.
It remains a mystery why Vermeer depicted her coat of arms. She
had died in 1624 and could not, therefore, have commissioned this
painting, and there is no evidence that Vermeer ever lived in her
former house, so he was not depicting his own surroundings. The
same coat of arms reappears in *The Girl with Two Men* (Plate 14), but
to confuse matters, similarly shaped leaded glass but without the
stained-glass centre appears in five other of Vermeer's paintings.

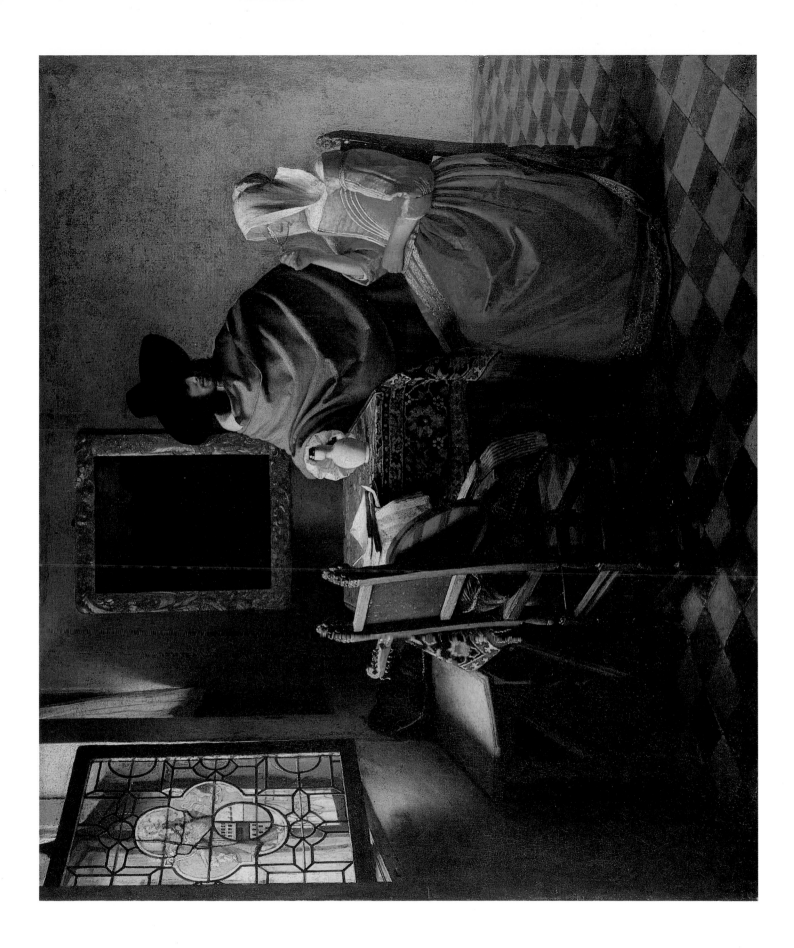

The Girl with Two Men

*c*1659–60. Oil on canvas, 78 x 67 cm. Herzog Anton Ulrich-Museum, Brunswick

At the back of the picture one of the men, either unlucky in love or simply drunk, sits dejectedly at a table on which stand a pitcher of wine, two oranges on a silver platter and a piece of paper which probably holds tobacco. The other man, who is similarly dressed, bends attentively over the seated girl, perhaps encouraging her to finish the glass of wine which she gingerly holds. The frivolous-looking young woman turns away from the two men to look directly at the viewer with piercing eyes and a rather curious smile. Although her silky dress is rendered with great care, her knees appear to be positioned much too far away from her torso.

On the back wall is a portrait of a gentleman dressed in dark clothing and a lace collar, whose dignified pose contrasts with the disreputable action which Vermeer hints may soon take place below him. The style of the portrait suggests that it dates from *c*1625–35, and it is possibly one of the family pictures that hung in the house of Maria Thins.

The room is the same as that in *The Glass of Wine* (Plate 13), although some details have been altered, such as the omission of the back window. However, the stained-glass centre of the leaded window with the figure of a woman and the coat of arms remains the same.

The Girl with Two Men was acquired by Anton Ulrich, the Duke of Brunswick (Braunschweig), as a Vermeer in 1711. His collection has been on view since 1754, making it Germany's oldest gallery open to the public.

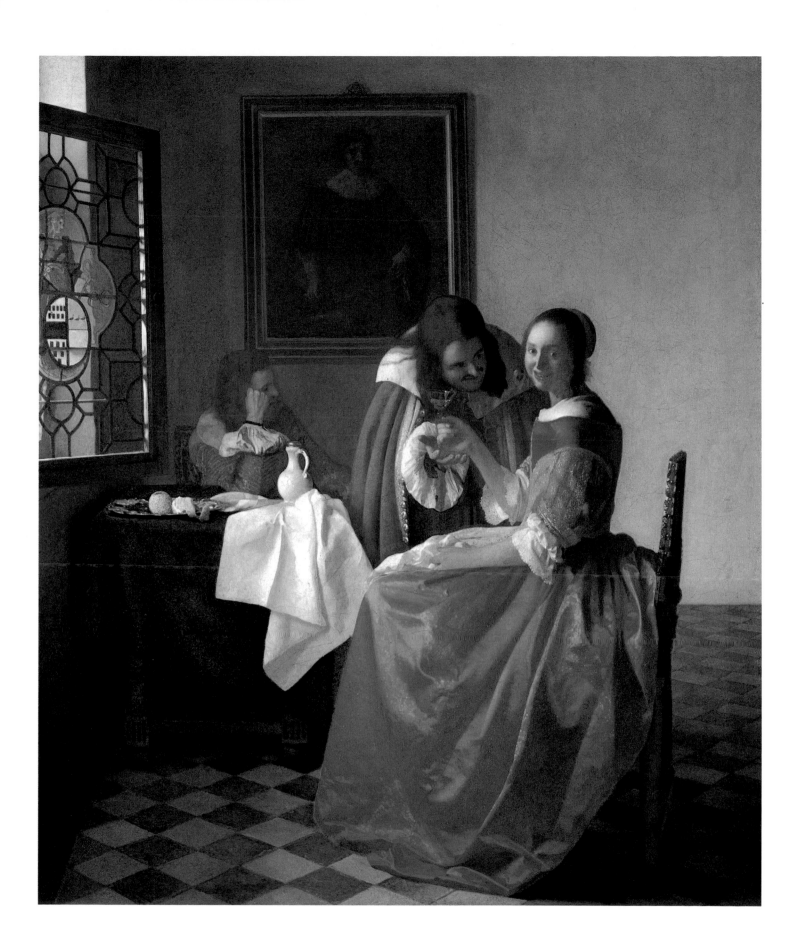

View of Delft

c1660–1. Oil on canvas, 97 x 116 cm. Mauritshuis, The Hague

Vermeer's magnificent townscape of Delft seen from the south has always been regarded as one of his masterpieces. In the 1696 auction of Dissius's 21 Vermeers, it was the most expensive picture, fetching 200 guilders. In 1822 the picture was bought by the Mauritshuis for the high price of 2,900 guilders, a purchase said to have been instigated by the Dutch King, Willem I. In the mid-nineteenth century *View of Delft* was the painting which inspired the French critic Théophile Thoré to rediscover Vermeer.

The picture is divided into four horizontal bands: the quay, the water, the town and the sky. On the left side of the quay are a mother and baby, and two fashionably dressed men and a woman talking together, and further towards the centre are two more women. The water represents a section of the River Schie, which eventually flows into the Rhine at Schiedam, near Rotterdam. The area of river depicted by Vermeer had been widened in 1614 to form a triangular pool which served as the harbour for Delft. Looking towards the town, the view is dominated by the ramparts and the Schiedam and Rotterdam Gates. The distant tower of the Old Church can only just be seen on the horizon on the left of the picture. Most of the town is in shadow, except for the sunlit New Church. The dramatic morning sky takes up over half of the picture; a tiny clock on the Schiedam Gate shows that it is just past 7 o'clock.

The view is from an elevated position, looking down onto the waterfront, and Vermeer may have painted the town from the upper floor of a house that is marked on contemporary maps just off the road named Hooikade. The pointillist technique that Vermeer used to suggest reflections flickering off the water, most easily visible on the two herring boats on the right, is evidence that he probably used a camera obscura to help compose the picture; diffused highlights such as these would appear when a partially focused image was obtained from this device.

The meticulous way that Vermeer worked on this masterpiece is shown by the fact that he mixed grains of sand into some of his paint to achieve a certain texture. An examination of the picture has revealed that the sand was added to the ochre used on the window frames of the long building to the left, behind the ramparts, giving a greater reflective quality to the paint surface.

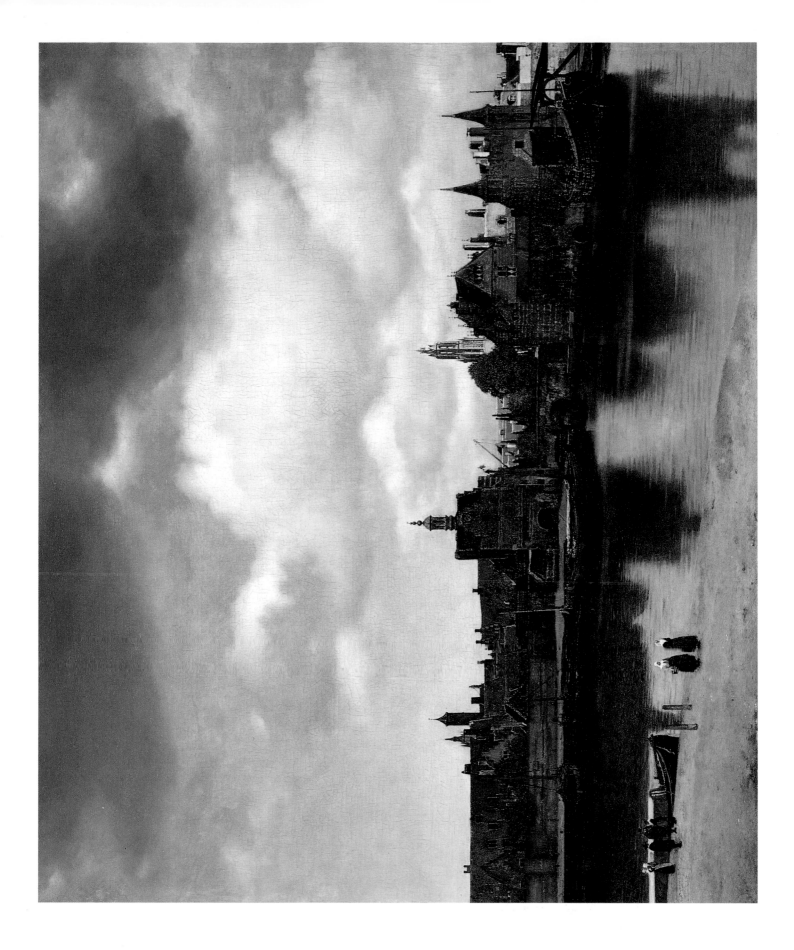

View of Delft shows the ramparts and the two fourteenth-century gates on either side of the stone bridge spanning the canal that passes through the town; on the far side of the bridge the water divides to become the Oude Delft and Nieuwe Delft canals. The Schiedam Gate with the clock-tower is on the left of the stone bridge and to the right is the Rotterdam Gate. Vermeer's home, Maria Thins's house in Oude Langendijck, would be just to the right of the tower of the New Church, although it is not visible in this picture.

Despite the impression of accuracy which the painting gives, Vermeer did not make a precise representation of the view. In a topographical drawing by Abraham Rademaecker (1675–1735), executed about half a century later from a similar vantage point, it is noticeable that the buildings appear taller and crammed closer together than in Vermeer's picture (Fig. 24). Vermeer seems to have shifted the buildings slightly to produce a more harmonious composition and this is most noticeable in the way he depicted the long section of the Rotterdam Gate.

Today the view from Vermeer's vantage point looks quite different, although the shape of the old harbour remains. The town's ramparts have long gone and the two gates were demolished between 1834 and 1836. Most of the medieval buildings near this part of the river have also been lost. The spire of the New Church burned down in 1872 and was replaced by a taller neo-gothic one. The original tower of the Old Church survives, although it has now developed a pronounced tilt.

Fig. 24
ABRAHAM
RADEMAECKER
View of Delft with
Schiedam and
Rotterdam Gates
Early eighteenth century.
Pen and ink on paper,
23 x 45 cm.
Stedelijk Museum, Delft

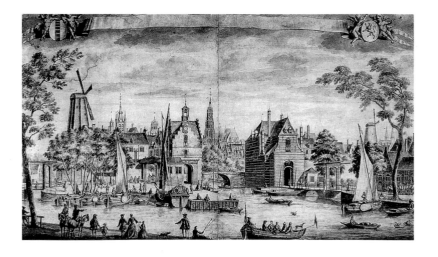

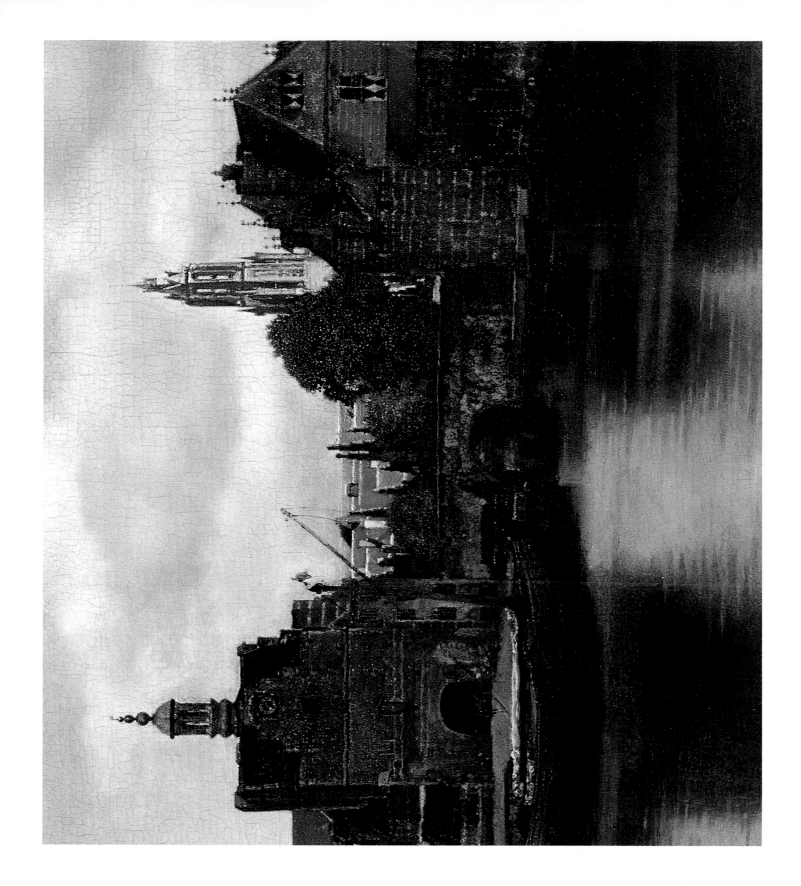

Girl Interrupted at her Music

*c*1660–1. Oil on canvas, 39 x 44 cm. Frick Collection, New York

The girl has been distracted and turns to look with a slightly quizzical expression. One wonders what has caused the interruption and why it has not yet disturbed her companion. She and the man are holding a sheet of paper, presumably a letter or a sheet of music. Once again, Vermeer presents an enigmatic scene, leaving it ambiguous whether the man is the girl's teacher or lover. The viewer is offered a privileged moment to look into the girl's eyes, just before her companion turns to see who has entered the room.

Music was often associated with love, and lying on the table are a cittern and an open music score, together with a blue and white Delftware pitcher and a single glass of red wine. On the rear wall is a full-length painting of Cupid, which is probably intended as a reminder that perfect love should be reserved for a single lover. The paint surface of *Girl Interrupted at her Music* is in worn condition and the birdcage hanging on the wall near the window may be a later addition by another artist.

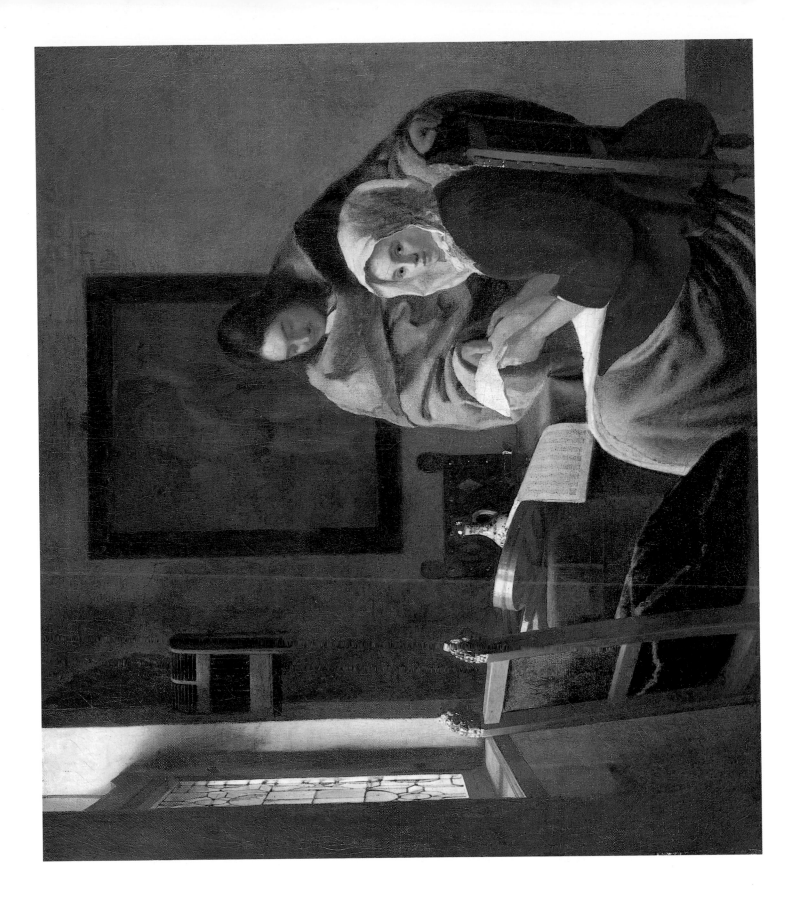

Woman in Blue Reading a Letter

*c*1662–4. Oil on canvas, 47 x 39 cm. Rijksmuseum, Amsterdam

The mood of the painting is calm and the woman is lost in thought, engrossed in reading a letter. On the table before her lie another page of the letter, a jewellery box and a string of pearls. The theme is similar to that of *Girl Reading a Letter at an Open Window* (Plate 7), which was painted about six years earlier, and although the woman seems to have aged, she shares similar facial features. It has been suggested that the model, who may be pregnant, could be Vermeer's wife, Catharina.

Although the woman is alone, the viewer is aware of the presence of the man who has written the letter, and the map of south-east Holland hanging on the wall hints at the world outside the confines of her room. This is the same map by Blaeu as that depicted in *Officer and Laughing Girl* (Plate 10) and *The Love Letter* (Plate 39), which suggests that Vermeer probably had a copy of it hanging in his house.

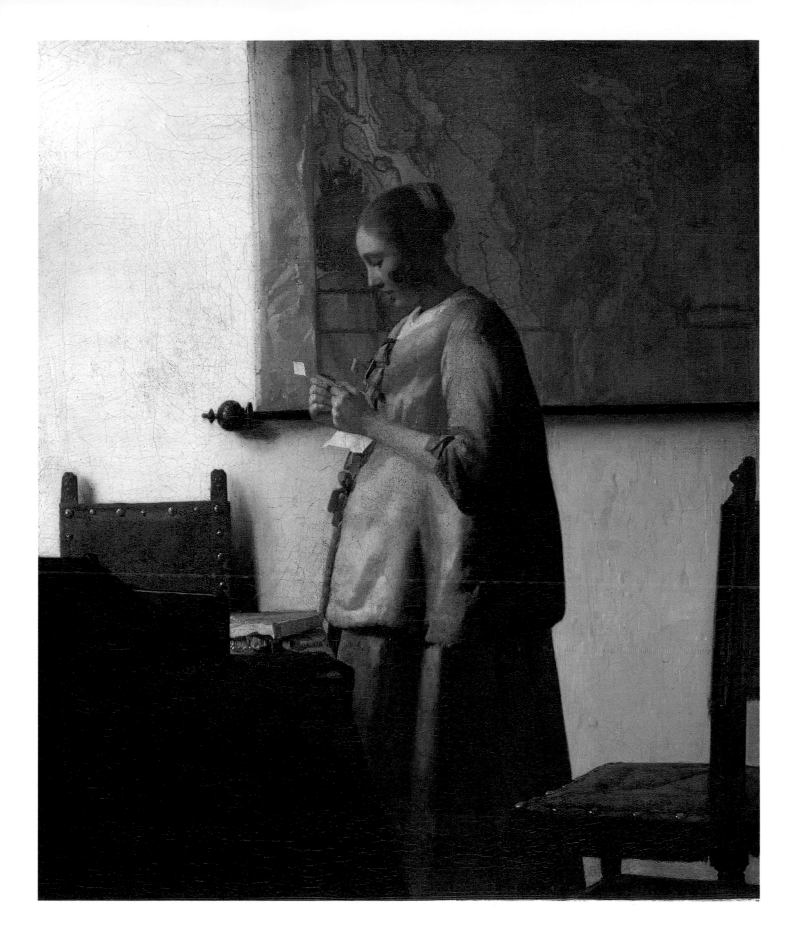

*c*1662–5. Oil on canvas, 73 x 65 cm. Royal Collection

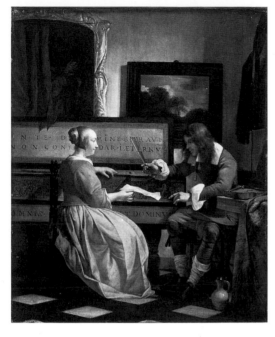

Fig. 25
GABRIEL METSU
Man and a Woman
Seated by a Virginal
*c*1665. Oil on panel,
38 x 32 cm.
National Gallery, London

A young woman plays the virginal, a type of small harpsichord, while an elegantly dressed man standing beside her, watches and listens intently. Once again, it is unclear whether he is her teacher or her lover.

On the underside of the lid of the virginal is an inscription that reads, 'Music is a companion in pleasure, a balm in sorrow'. The instrument (and the inscription) is similar to those made by Andries Ruckers of Antwerp in the early seventeenth century. On the floor behind the woman lies a viol, resting in a rather vulnerable position, which suggests that the man may have been playing a duet with her before temporarily laying down his instrument.

Part of a painting is visible on the right of the rear wall. It is a representation of Roman Charity in which a naked man with chained arms can just be discerned. In the ancient story of filial piety, Cimon, who had been condemned to starve to death, is suckled by his daughter Pero. The painted version depicted here seems to have been by an Utrecht follower of Caravaggio, such as Gerrit van Honthorst (1590–1656) or Matthias Stomer (*c*1600–49). The original picture could have belonged to Maria Thins, since a 1641 inventory drawn up after her divorce records 'a painting of one who sucks the breast'.

Vermeer composed *The Music Lesson* very carefully, with a series of horizontal lines made up by the ceiling beams, the mirror, the virginal and the table-top, which contrast with the diagonal floor tiles. The warm light flooding into the room is used to emphasize the texture of objects such as the pile of the Oriental rug, the smooth porcelain pitcher and the brass studs on the blue-covered chair. The composition has interesting parallels with Metsu's *Man and a Woman Seated by a Virginal* (Fig. 25), which is probably from a later date.

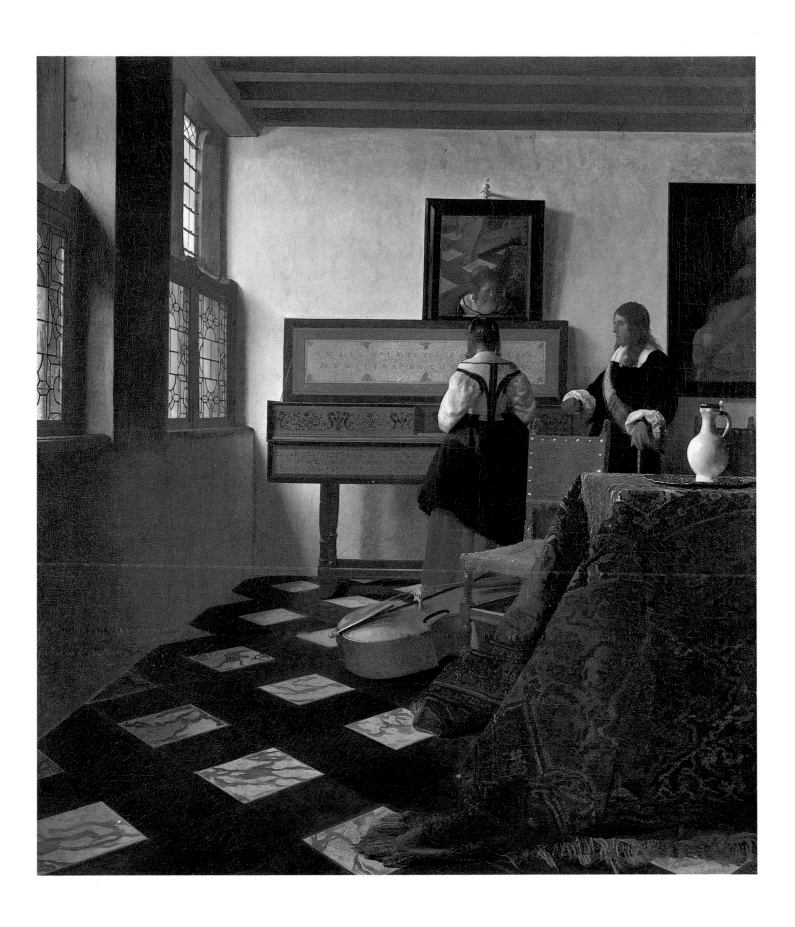

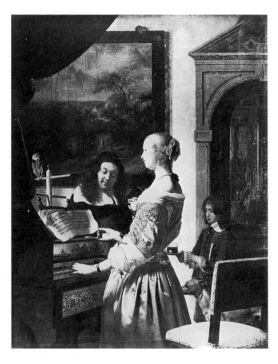

Fig. 26
FRANS VAN MIERIS
The Duet
1658. Oil on panel,
32 x 25 cm.
Staatliches Museum,
Schwerin

Above the virginal hangs a mirror, in which the young woman's face and shoulders can be seen, turning towards the man. The image in the mirror is painted at a slightly different angle than her actual position would suggest. Her reflection is also slightly out of focus and diminished in scale, representing the optical effects of a mirror that other artists of the time did not usually portray accurately, and a sign of Vermeer's observation and skill.

In the mirror, above the reflection of the woman, can be seen the corner of the table covered with the rug, together with the lower part of the artist's easel and a box that probably contains his materials, or is possibly a camera obscura. These objects are a subtle reminder of the presence of the artist.

The painting was bought in 1742 by Consul Joseph Smith from the widow of the Venetian painter Giovanni Pellegrini (1675–1741). When George III acquired Smith's collection 20 years later, the picture was attributed to Van Mieris. This was an understandable attribution since there is a slightly earlier painting of a woman at a virginal by Van Mieris which Vermeer may have known (Fig. 26). *The Music Lesson* was not recognized as a Vermeer until the 1860s.

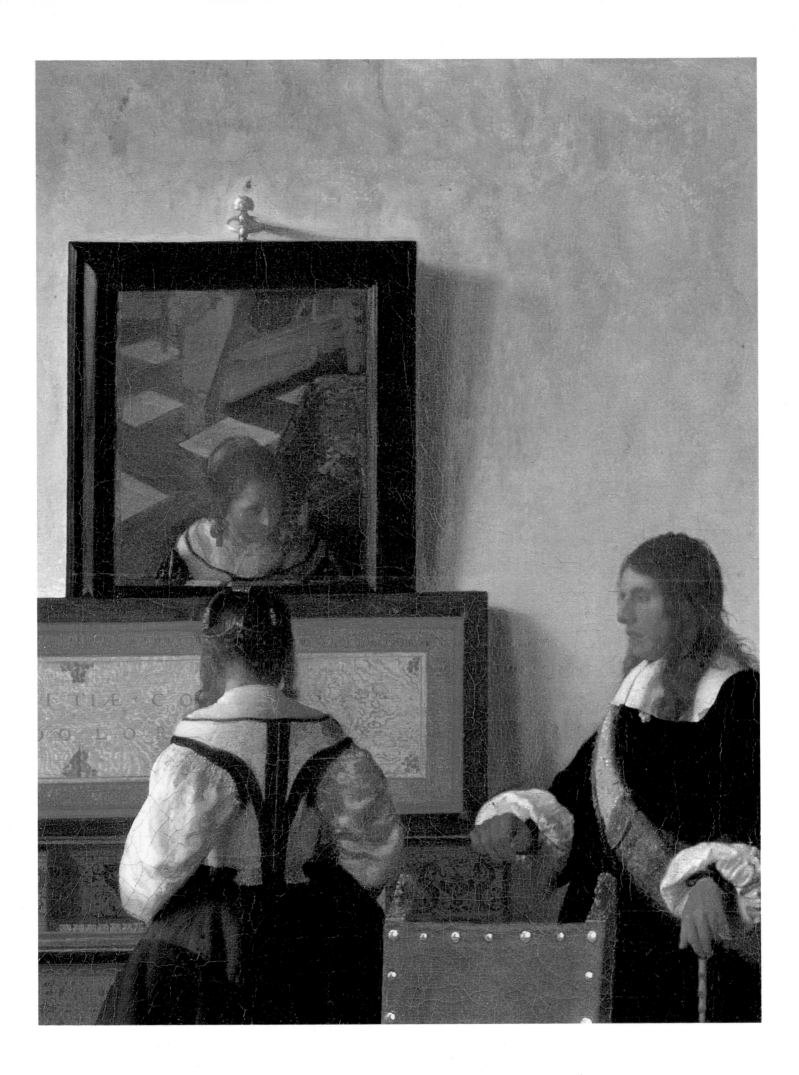

Woman Holding a Balance

*c*1664. Oil on canvas, 40 x 36 cm. National Gallery of Art, Washington, DC

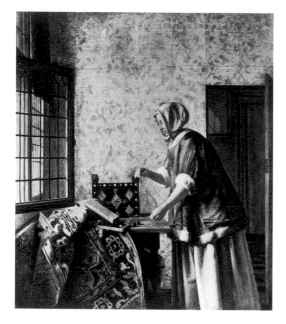

Fig 27
PIETER DE HOOCH
Woman Weighing
Gold
*c*1664. Oil on canvas,
61 x 53 cm.
Gemäldegalerie,
Staatliche Museen zu
Berlin – Preussischer
Kulturbesitz, Berlin

The woman gently holds a balance in her right hand, carefully steadying it. Her eyes are lowered to focus on it and her left hand rests on the table to help keep her body motionless. The composition is very carefully arranged, with the picture divided in half diagonally into areas of sunlight and shadow, with the scales poised in the centre. The dark painting on the back wall occupies almost exactly a quarter of the canvas. On the table is a jewellery box, from which a string of pearls spills out, and another smaller box, together with several gold coins. The woman does not appear to be tempted by the precious objects before her, and she shows no interest in the mirror which can just be seen on the wall in front of her. Unlike most of Vermeer's women, she wears no jewellery.

The woman's head is, in effect, framed by the painting hanging on the wall behind her. This is a depiction of *The Last Judgement*, probably a version by a late sixteenth-century Flemish artist, such as Jacob de Backer (1540–95). The painting shows Christ sitting in majesty, while below him to the left, the blessed are led up to heaven, and to the right, the damned are conveyed to hell. Although hidden by the head of Vermeer's woman, the figure of the archangel Michael would be in the centre of the lower part of the composition, weighing souls.

Vermeer's picture probably influenced De Hooch's *Woman Weighing Gold* (Fig. 27), which is also likely to date from *c*1664, but De Hooch's version lacks the magical tranquility of the Vermeer.

When *Woman Holding a Balance* was cleaned in 1994, paint that had been added by an earlier restorer along the outside edges of the canvas was removed, slightly reducing the size of the painting.

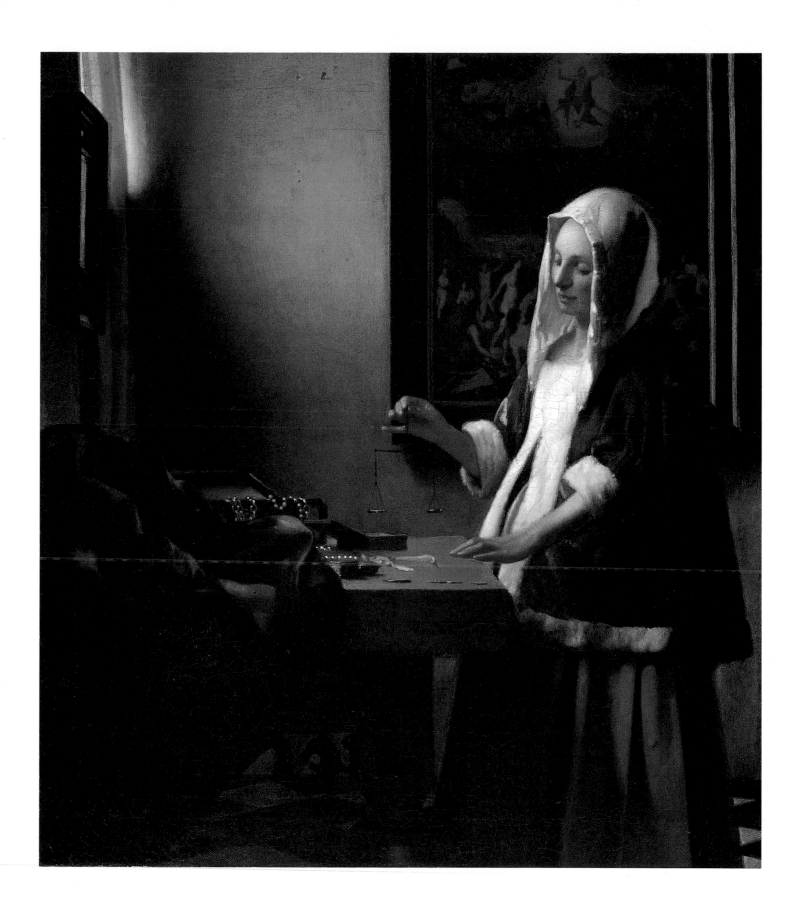

It has long been assumed that the scales held by the woman contain either gold or pearls. In the 1682 sale of Dissius's collection the painting was described as 'a young lady, weighing gold' and at an 1830 auction the woman was called 'a pearl weigher'. However, a microscopic examination has revealed that both pans are empty. Vermeer could not have expected his viewers to look so closely at his picture, so it is likely that the ambiguity as to what she was weighing, or whether she was weighing anything, was deliberate. Vermeer is inviting us to ponder on the theme of judgement.

Woman with a Pearl Necklace

*c*1664. Oil on canvas, 55 x 45 cm. Gemäldegalerie, Staatliche Museen zu Berlin – Preussischer Kulturbesitz, Berlin

The woman holds her pearl necklace up to the light. She might be simply grasping the ends of the yellow ribbon in order to fasten it, but she seems to be wondering whether it is the appropriate piece of jewellery to wear. The woman is caught in a moment of time, quietly admiring herself in the mirror on the wall. Curiously, the mirror is surprisingly small and appears to be hung too high for her to see the reflection of her necklace. Its dark position just next to the bright light of the window would also make it difficult to use. On the table are a face-powder brush, a small comb, a silver-lidded box or a plate and a large Chinese-style jar near the window. On the far side of the table near the wall the back of an ornate chair can be seen.

This picture is probably the 'painting representing a woman wearing a necklace' which was in Catharina's bedroom at the time of Vermeer's death. The artist seems to have kept only four of his own pictures. This suggests that *Woman with a Pearl Necklace* had a special importance and raises the possibility that Catharina might have been the model. However, she would have been about 33 when it was painted, so if Vermeer did portray her, he gave her more youthful features.

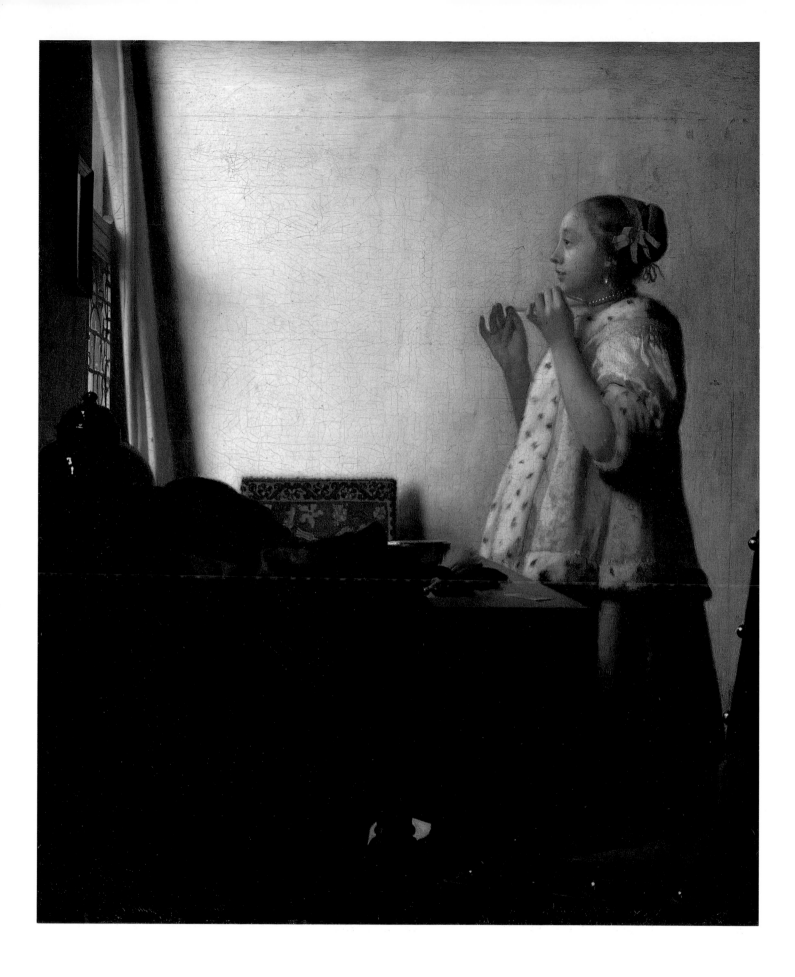

Woman with a Lute

*c*1664. Oil on canvas, 51 x 46 cm. Metropolitan Museum of Art, New York

The woman appears to be tuning her lute; gazing out of the window, she listens intently as she adjusts the peg with her left hand while plucking a chord with her right. What, we wonder, is she watching outside the confines of her room?

On the rear wall hangs a map of Europe, identified as one first published by Jodocus Hondius in 1613 and reprinted in 1659 by Joan Blaeu. Presumably the papers or books in front of the woman are musical scores. Lying on the floor, but no longer clearly visible in an area of damaged paint, are a music book and a viol, perhaps ready to be played by a companion for whom she is waiting. Although accepted by most scholars, Blankert has questioned the authenticity of the painting due to its poor condition. However, the fact that its whereabouts can be traced from 1817 and that it carries a signature strengthens the case for its authenticity.

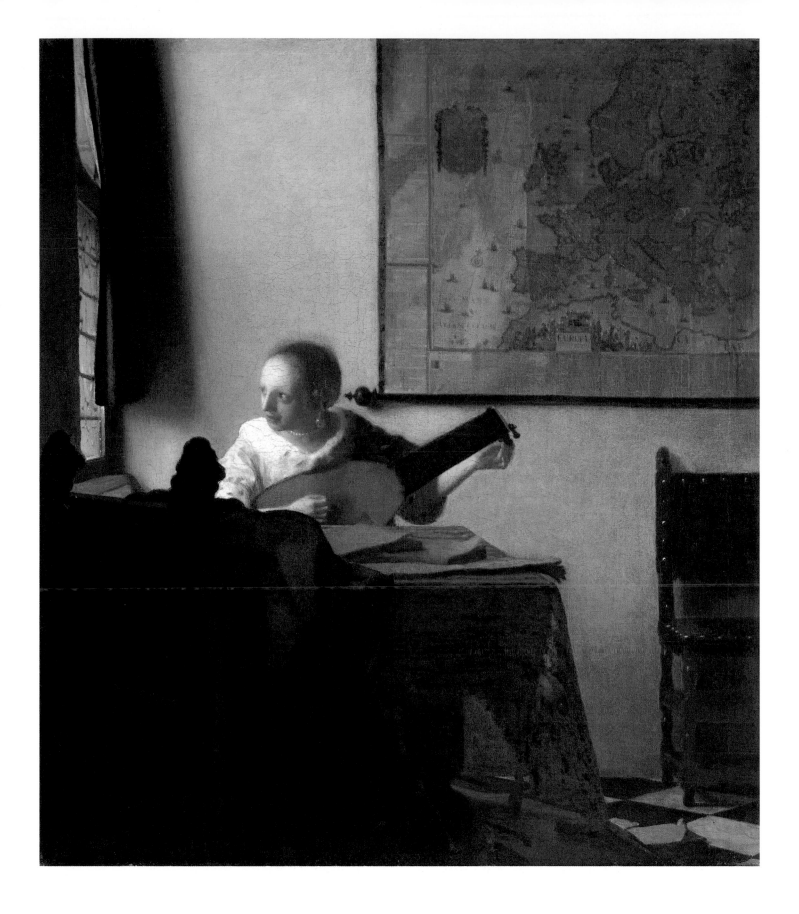

Young Woman with a Jug

*c*1664–5. Oil on canvas, 46 x 41 cm. Metropolitan Museum of Art, New York

The young woman appears to be opening the window and holding a pitcher simultaneously, a curious combination of movements. However, as a result of these actions, her outstretched arms span the painting and serve to link the various elements of the composition.

Vermeer has captured the effect of the sunlight which floods in and illuminates the back wall. It is also reflected off the gilded jug, which probably contains water (some art historians have claimed that it would have held wine, imparting quite a different meaning to the painting). Also on the table is an ornate jewellery box, with a blue ribbon and part of a pearl necklace just visible at the top. On the wall hangs a map by Huyck Allart of the seventeen provinces of the Netherlands, only the southern half of which is shown (north is orientated to the right). The only surviving copy of Allart's map (Fig. 28) is dated 1671, but there must have been an earlier edition that Vermeer depicted in his painting.

Fig. 28
HUYCK ALLART
Map of the Seventeen Provinces of the Netherlands
1671. Engraving.
Bibliotheek der Rijksuniversiteit, Leiden

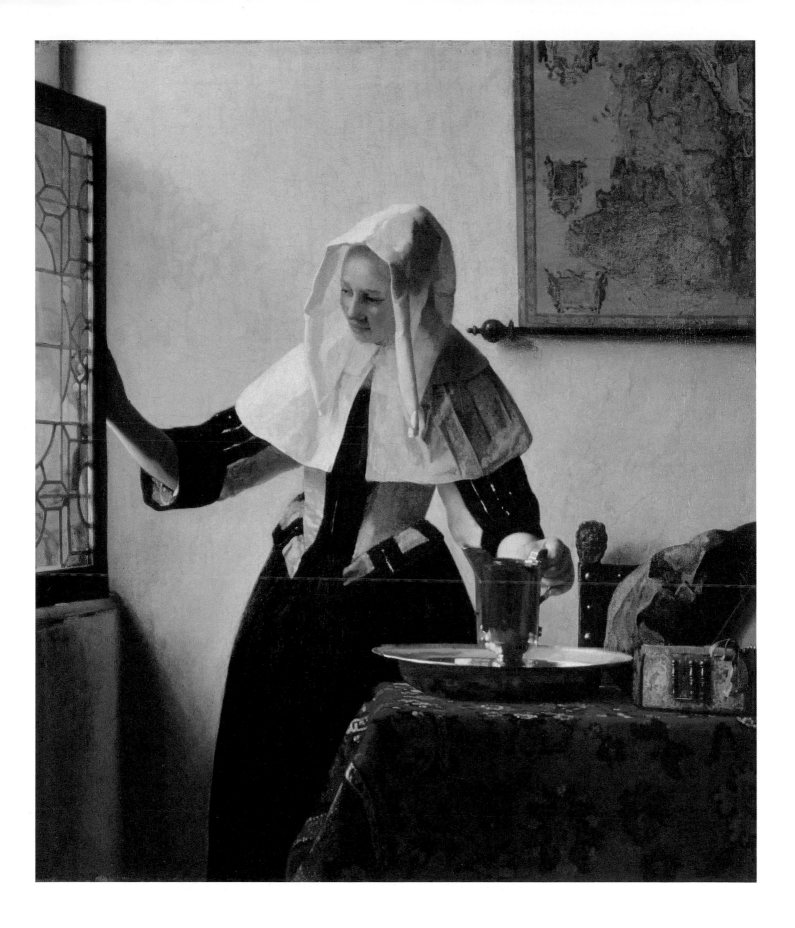

The Girl with the Pearl Earring

*c*1665. Oil on canvas, 45 x 39 cm. Mauritshuis, The Hague

The girl turns to look over her left shoulder at the viewer, her lips slightly open as if she is about to speak. She is dressed in a light brown jacket, a white blouse, and a blue and yellow turban or headscarf. The painting is set against a very dark background, which has the effect of drawing the eye into the composition and giving the girl a three-dimensional appearance. Vermeer deliberately blurred the details of her face with the bridge of her nose and her cheek merging together.

The large tear-shaped pearl earring appears in a number of Vermeer's paintings, including *Mistress and Maid* (Plate 35). In this picture it stands out distinctly against the girl's neck, which is in shadow, and this emphasizes the large spot of reflected light on the pearl. Until 1994, when the painting was restored, there was a second 'reflection' on the pearl, slightly lower down and to the right. This spot, which is clearly visible in earlier colour reproductions of the picture, was found to be a flake of paint which had accidentally stuck to the canvas during a previous restoration, probably in 1882. Despite its small size, this speck of paint considerably altered the appearance of the earring and was, therefore, removed.

There has been much discussion over whether the picture is a portrait of a specific person or an idealized figure. It is tempting to speculate that one of Vermeer's daughters might have been the model, but in 1665 his eldest daughter, Maria, was only about 11 years old.

The Girl with the Pearl Earring was sold at auction in 1882 for two and a half guilders, less than £1. Soon afterwards the painting was identified as a Vermeer and it was given to the Mauritshuis in 1903.

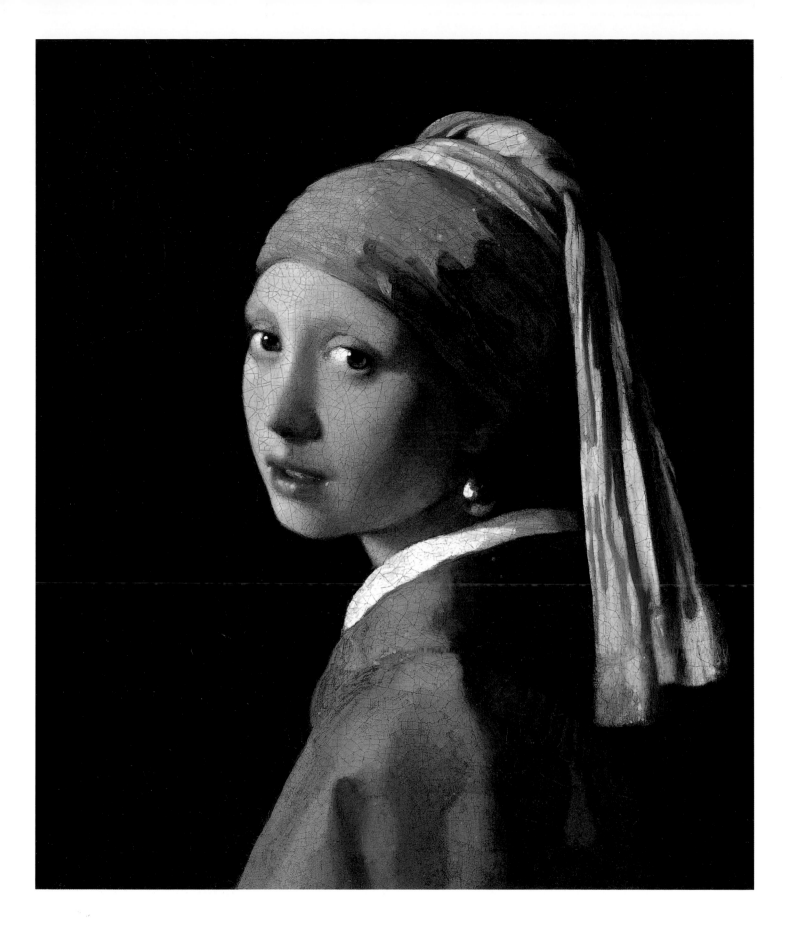

A Lady Writing

c1665. Oil on canvas, 45 x 40 cm. National Gallery of Art, Washington, DC

Vermeer may have been influenced by the composition of *Woman Writing a Letter* by Ter Borch, who had tackled this subject a decade earlier (Fig. 29). This theory has gained weight with the discovery that Vermeer had long known the artist (the two men cosigned a legal document in 1653).

On the wall behind the woman hangs a picture of a still life with a viol, although the details are now difficult to distinguish. It is a painting on the theme of the transience of life and the inevitability of death, known as a *vanitas*. It may be the picture of 'a bass viol with a skull' which, according to the 1676 inventory, was in Vermeer's dining room.

A Lady Writing once hung in the Bahamas. In 1940 it was bought by the colony's magistrate, Sir Harry Oakes, who was murdered by the Mafia three years later for opposing a casino licence. The painting was sold by his widow to the American collector Horace Havemeyer and given to Washington's National Gallery of Art by his two sons in 1974.

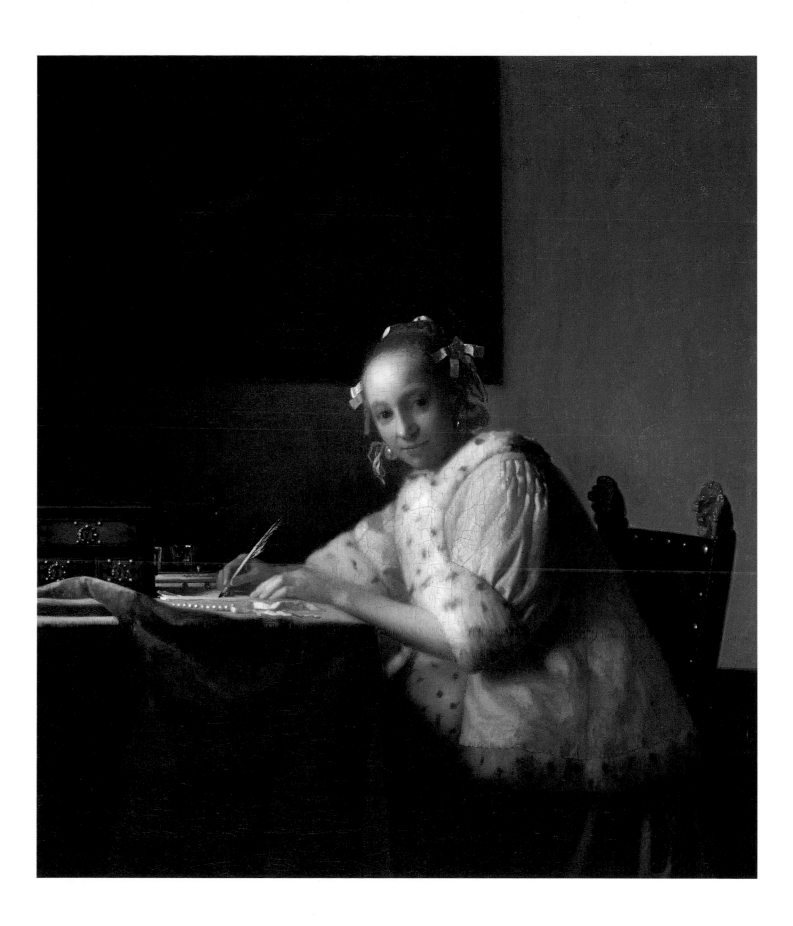

The young woman turns round from her table, looking at the viewer with a hint of a smile. She holds a quill in her right hand and her left hand rests gently on the letter she is writing. The woman is fashionably dressed, and Vermeer has captured marvellously the texture of the luxurious fur-lined mantle. She has pearl earrings, and bows in her hair which highlight her face almost like a halo. On the table beside her are a pearl necklace tied with a yellow ribbon, an ornate jewellery box and, at the back, an inkwell. Among all of Vermeer's women, she has a particularly haunting beauty.

Fig. 29
GERARD TER BORCH
Woman Writing a
Letter
*c*1655. Oil on panel,
39 x 30 cm.
Mauritshuis, The Hague

Girl with a Red Hat

*c*1665. Oil on panel, 23 x 18 cm. National Gallery of Art, Washington, DC

The girl, wearing a flaming red hat, turns to look over her right shoulder, sunlight illuminating her left cheek, the tip of her nose, her white lace collar, and the shoulder of her blue robe. Her mouth is slightly open, as if she is about to speak, and her eyes are expectant. On the wall behind her hangs a tapestry.

Girl with a Red Hat is painted on a wood panel, which gives it a more luminous surface than if it were on canvas. The only other painting on panel that has been attributed to Vermeer is *Girl with a Flute* (Plate 30), although the 1676 inventory records that he had six un-painted panels in his studio.

X-rays have revealed that *Girl with a Red Hat* is painted over a half-length portrait of a male that does not seem to be by Vermeer, but is more in the style of the work of Fabritius of the late 1640s. Vermeer owned two portrait heads by Fabritius at the time of his death and, as an art dealer, others might well have passed through his hands. It remains unclear why he reused an existing painted panel.

The curious position of the chair in the foreground has been much discussed. This chair, with its lion-head finials, features in many of Vermeer's paintings with the heads facing forwards, such as in *A Lady Writing* (Plate 27). Assuming that the girl is sitting on the chair, turning round completely to look at the viewer with her right arm along its back, the lion heads are facing the wrong direction. The finials also seem to be set slightly low and too close together, making it an uncomfortably narrow chair.

The authenticity of *Girl with a Red Hat* has been questioned by some scholars, partly because of the clumsy depiction of the chair. Blankert has even claimed that it was painted in France in the eighteenth or early nineteenth century. However, most scholars now accept it as genuine, as scientific examination has shown that the pigments are characteristic of the seventeenth century and the lead white is similar to that used by Vermeer. The painting appeared on the art market in Paris in 1822 attributed to Vermeer, and this early date also strengthens the case for its authenticity.

Girl with a Flute (circle of Vermeer)

*c*1665. Oil on panel, 20 x 18 cm. National Gallery of Art, Washington, DC

The attribution of this small panel painting is even more controversial than *Girl with a Red Hat* (Plate 29). Although the wind instrument in the girl's left hand has usually been called a flute, it is not very clearly depicted and could be a recorder. This poor representation of a musical instrument is rare in the work of Vermeer.

The girl's hat is unusual; its shape is similar to that of a Chinese coolie hat, which would have been considered an exotic curio in the Netherlands at the time. However, it is not made of straw and the parallel stripes would have been impossible to produce on a conical shape. Although the hat has been cited as evidence that the painting is a fake, it is strange that a forger should have invented such bizarre headwear.

Scientific examination of the picture suggests that it does indeed date from Vermeer's time. A dendrochronology analysis of the oak panel, based on an examination of tree rings, shows that the tree was felled in the early 1650s and, since wood needs to be seasoned before use, this is quite consistent with a painting dating from *c*1665. This refutes the suggestion that it is a nineteenth-century fake, unless the forger had managed to find a panel of just the right period.

It has been suggested that the picture could be the work of one of Vermeer's children, although there is no evidence that any of them painted. Another possibility is that the painting might have been started by Vermeer and completed after his death by another artist, such as the Haarlem painter Jan Coelenbier (active from 1632), who bought pictures from Catharina in 1676.

Girl with a Flute was discovered in a private collection in Brussels by Abraham Bredius, who exhibited it at the Mauritshuis in 1906. It was bought by the American collector Joseph Widener in the 1920s and given to the National Gallery of Art in Washington in 1942. There still remains considerable disagreement about the attribution. Blankert rejects it completely and Wheelock believes that the painting should be 'attributed' to Vermeer. For the moment 'circle' of Vermeer may well be a fairer assessment, in that it is probably not from the master's hand, but by another artist of the period working in his style.

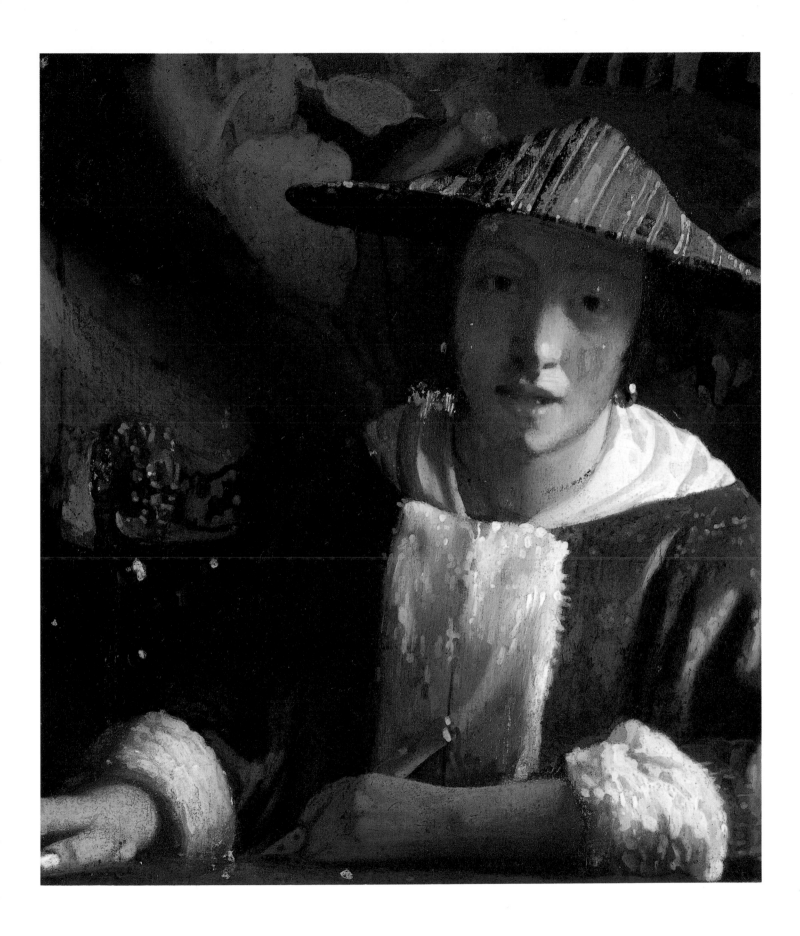

*c*1665–6. Oil on canvas, 73 x 65 cm. Isabella Stewart Gardner Museum, Boston, MA (stolen 1990)

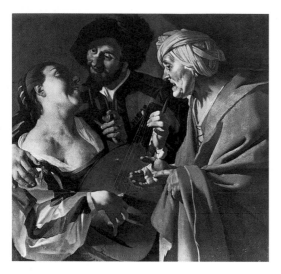

Fig. 30
DIRCK VAN BABUREN
The Procuress
1622. Oil on canvas,
101 x 107 cm.
Museum of Fine Arts,
Boston, MA

The musical trio includes a woman playing a harpsichord, a seated man with a lute, of which only a small section of the neck and the peg box are visible near his left shoulder, and a woman singing an accompaniment. All three are deep in concentration, and the mood is restful.

In the foreground of the painting is a table covered with an Oriental rug on which there lie musical scores and a cittern, and beneath the table is a viol. The pattern of the black and white floor tiles draws the eye towards the musical trio gathered around the instrument.

The underside of the harpsichord's lid is decorated with a painting of a tranquil landscape scene. On the back wall hang two pictures: the wooded landscape on the left is in the sombre style of the Haarlem artist Jacob van Ruisdael (1628/9–82), and the picture on the right is Dirck van Baburen's *The Procuress* (Fig. 30). Since the latter also appears in another of Vermeer's paintings, *A Lady Seated at the Virginal* (Plate 48), it is presumed that the work hung in his house. Further evidence for this is the inventory made after the divorce of Maria Thins in 1641, recording 'a painting wherein a procuress points to the hand'. Attempts to trace the history of the Van Baburen picture suggest that in the eighteenth century it was owned by Sir Hans Sloane, whose collection formed the basis of the British Museum in 1759. If so, it was not included in his bequest to the museum, and the painting was eventually acquired by Boston's Museum of Fine Arts in 1950.

Vermeer's *The Concert* also came to Boston. It was owned by the French critic, Thoré and sold by his heirs in 1892 to the wealthy American collector Isabella Stewart Gardner, whose house became a museum on her death in 1924. The painting was the most important work lost when 11 pictures were stolen from the museum on 18 March 1990 and it has not yet been recovered.

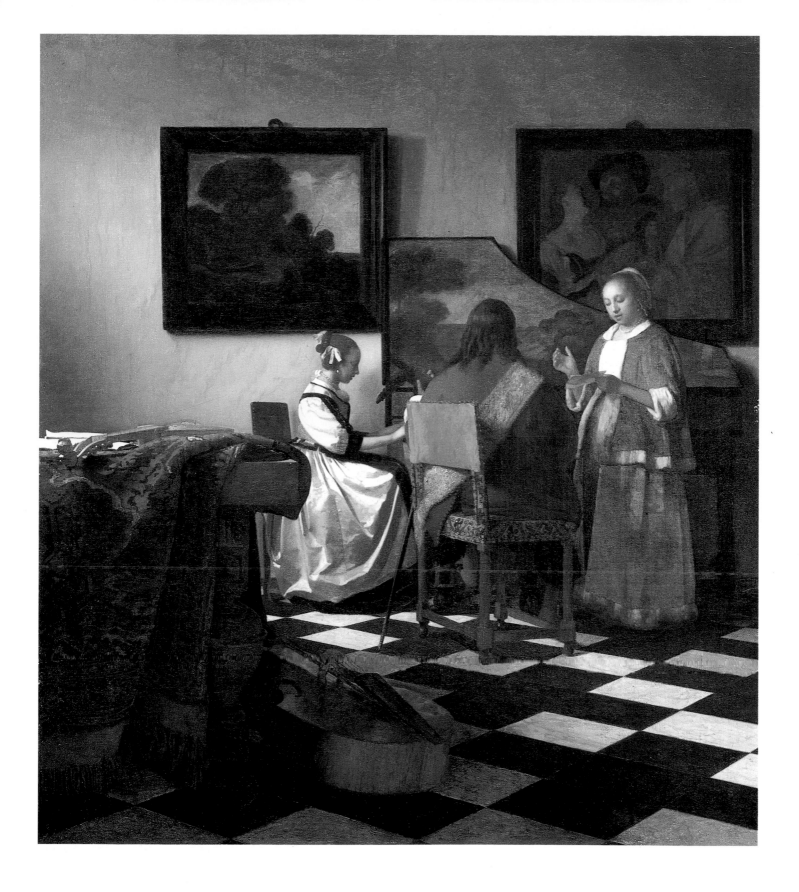

The Art of Painting

c1666–7. Oil on canvas, 120 x 100 cm. Kunsthistorisches Museum, Vienna

In this allegorical picture the artist is painting Clio, the Muse of History. Standing in the sunlight, the model holds a trumpet in her right hand, representing Fame, and a large book in her left hand, representing History. Vermeer's source is a reference in Cesare Ripa's *Iconology*, an Italian study of classical symbols which was published in Dutch in 1644. Ripa describes Clio as 'a maiden with a laurel garland, who holds a trumpet in her right hand and with the left a book'.

The richly patterned curtain draped across the top left-hand corner gives the room a stage-like appearance. On the far wall is a map by the Amsterdam cartographer Nicolaes Visscher, of the United Netherlands (with north to the right) showing the Dutch republic before it was formally divided into southern and northern provinces in 1648. Some commentators have suggested that the prominent vertical split in the middle of the map depicted in Vermeer's painting might symbolize the break-up of the Dutch republic. However, the crack is more likely to be simply an indication of the map's age, illustrating Vermeer's great attention to detail in achieving the greatest possible realism.

The Art of Painting was one of the few pictures that remained in Vermeer's possession at the time of his death, suggesting that it was particularly precious. In February 1676 Catharina transferred ownership of a picture which 'depicted the Art of Painting' to her mother, Maria, presumably to prevent it being sold in the face of bankruptcy. The agent acting for her creditors did indeed try to get the painting sold to raise funds, although its fate is unknown for well over a century.

In 1813 the painting, then believed to be by De Hooch, was acquired from an Austrian saddlemaker by Johann Rudolf, Count Czernin, for just 50 florins. *The Art of Painting* remained in the Czernin's collection until 1940, when it was sold to the Nazi art adviser Hans Posse, who was buying works on behalf of Hitler. The picture was first taken to Munich and later hidden underground in the Alt Aussee salt mine in Austria. When it was found by American forces in 1945, the National Gallery of Art in Washington, although having no legal claim, made efforts to acquire it. Ultimately the American forces returned the painting to Austria and, because the Czernin family were deemed to have sold it voluntarily to the Nazis, it was retained by the government. *The Art of Painting* was transferred to the Kunsthistorisches Museum in 1946.

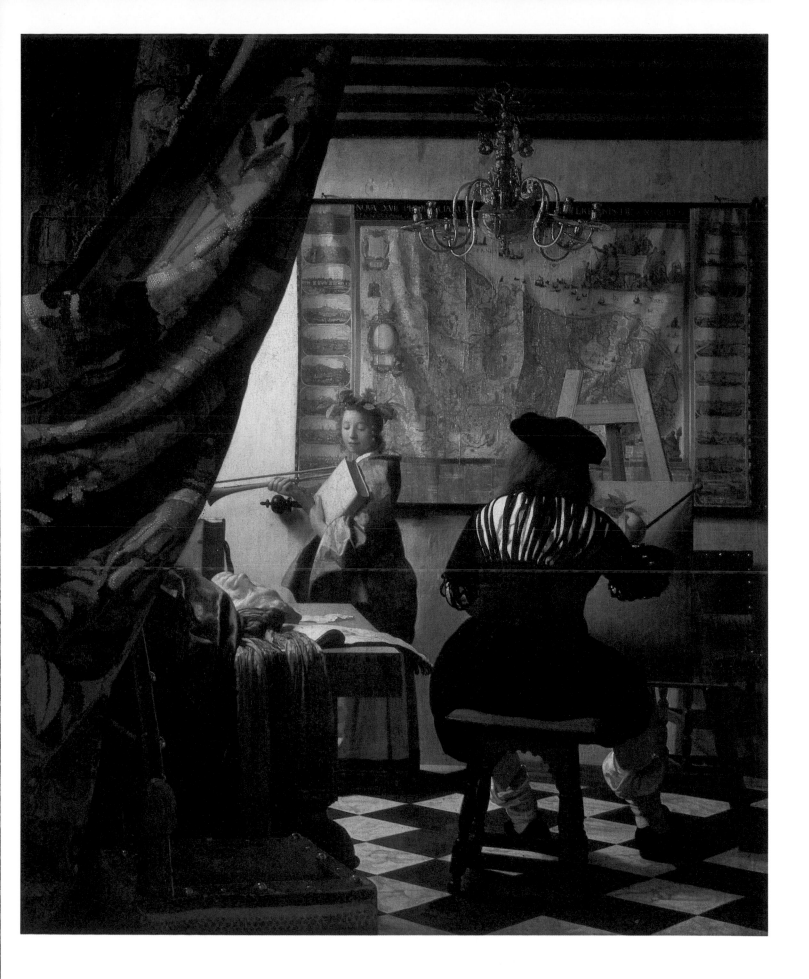

Clio, the Muse of History, wears a crown of laurel leaves (the blue colour is probably due to the deterioration of the original green pigment) and holds her trumpet and book. She stands motionless, her downcast eyes turned towards an oak table, on which there are a large manuscript book, probably of drawings or music, some drapes and an oversized mask, the edge of which is just visible on the left of the detail shown.

The long-haired artist, who turns his head to study his model, probably represents Vermeer. He is wearing a floppy velvet beret, slitted jacket and breeches, very similar to the fanciful attire worn by the grinning observer in *The Procuress* (Plate 4).

The picture should not be regarded as a literal depiction of an artist's studio; the elegant room has few signs of the clutter that would be expected there. A brush, barely visible, and a maulstick are shown, but there is no sign of any paints, although presumably there is a palette hidden behind the artist's left shoulder. It is curious that the artist should begin the figure by painting the laurel wreath, rather than the face; also, a maulstick would normally be unnecessary when there was little paint on the canvas. All this is a reminder that *The Art of Painting* is an allegory.

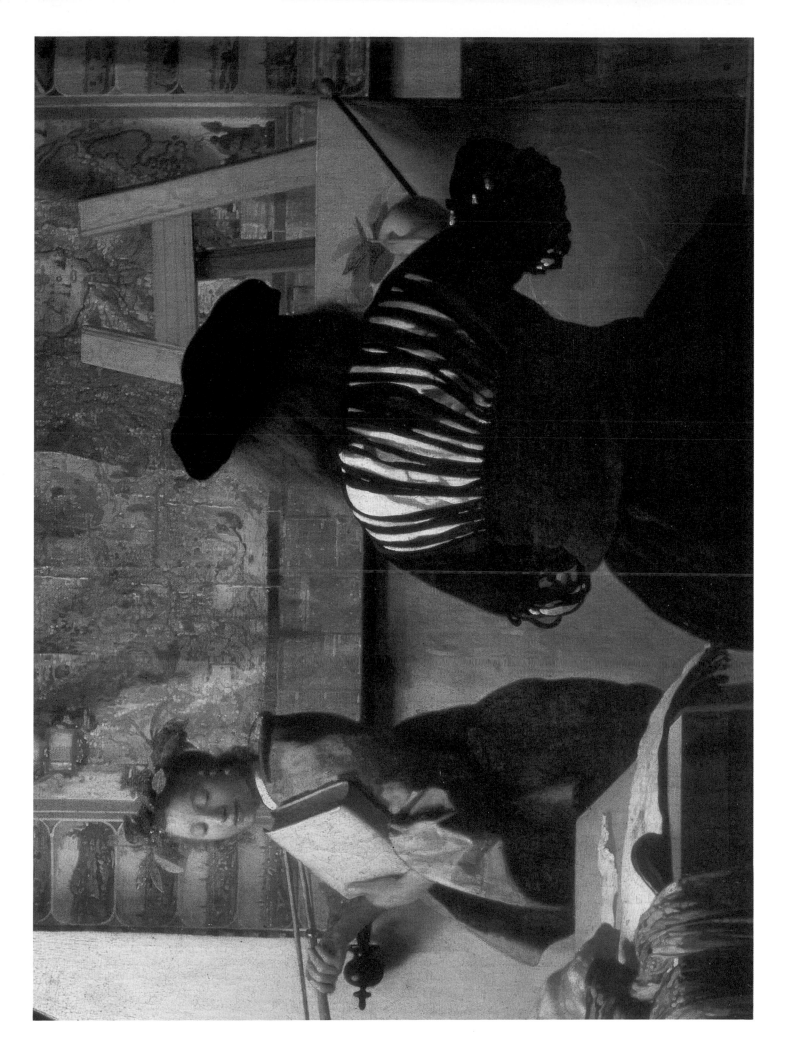

Head of a Young Woman

*c*1666–7. Oil on canvas, 45 x 40 cm. Metropolitan Museum of Art, New York

This may well be a portrait depicting a particular young woman, rather than an idealized figure. It has been suggested that the girl could be Vermeer's eldest daughter, Maria, although she would have been only 12 or 13 years old in 1666–7. If the painting is dated to 1672, as Blankert believes, then Maria would have been 18, which would make this theory more plausible.

The face of the young woman, who has an air of purity, is softly modelled and her expression is slightly vacant. Her hair is swept back and held in a turban or scarf, emphasizing her forehead, and she wears large pearl earrings. Although the face is very carefully painted, the white drapery is loosely brushed in and the trace of her right arm visible at the bottom of the picture is clumsy.

Head of a Young Woman was one of the last Vermeers to be in a private collection; it was given to the Metropolitan Museum of Art in 1979 by Mr and Mrs Charles Wrightsman.

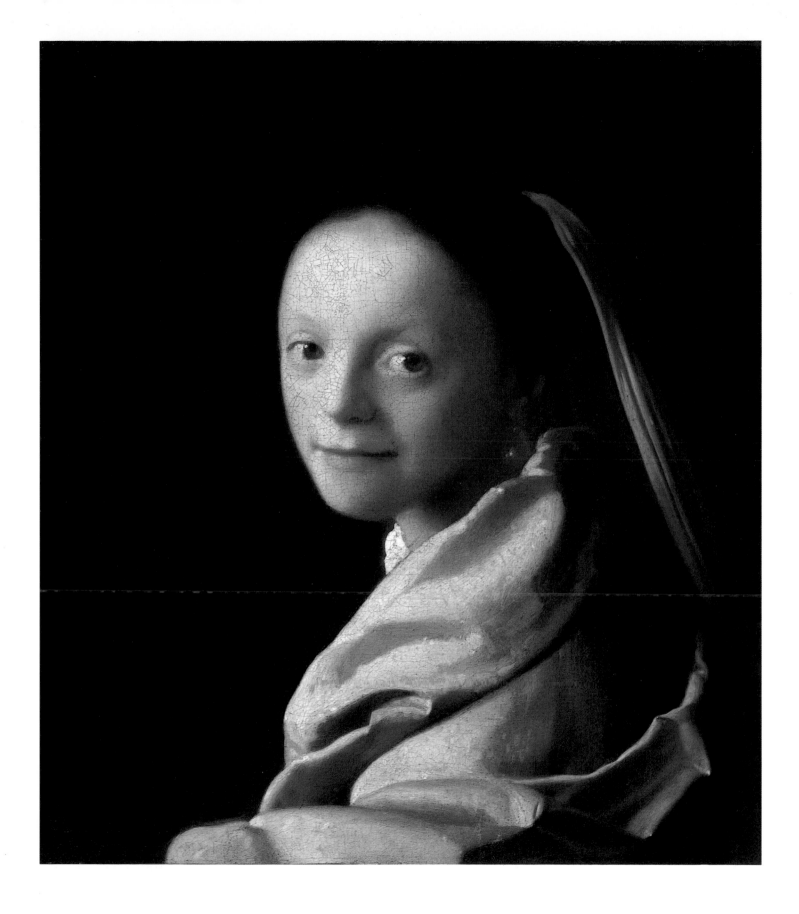

Mistress and Maid

*c*1667–8. Oil on canvas, 92 x 79 cm. Frick Collection, New York

The maid, plainly dressed in a brown bodice and blue apron, leans over towards her mistress, holding a letter gingerly in her right hand. As she turns towards her maid the mistress raises her left-hand fingers to her chin in a gesture of apprehension, so we see little of her expression. Although it is often assumed that the maid is handing her a letter which has just arrived, the quill in the mistress's right hand suggests that the maid may be asking for instructions on where to deliver a note. However, this does not explain why the mistress is dressed in a fur-trimmed jacket, with pearl earrings, a pearl necklace and a string of small pearls in the bun of her hair, all of which seem to be unusually elegant attire for simply writing a letter at home.

Mistress and Maid, or perhaps more likely *Lady Writing a Letter with her Maid* (Plate 43), may have been the painting 'representing two persons one of whom is writing a letter' which Catharina gave to the baker, Van Buyten, in settlement of the family's bread bill.

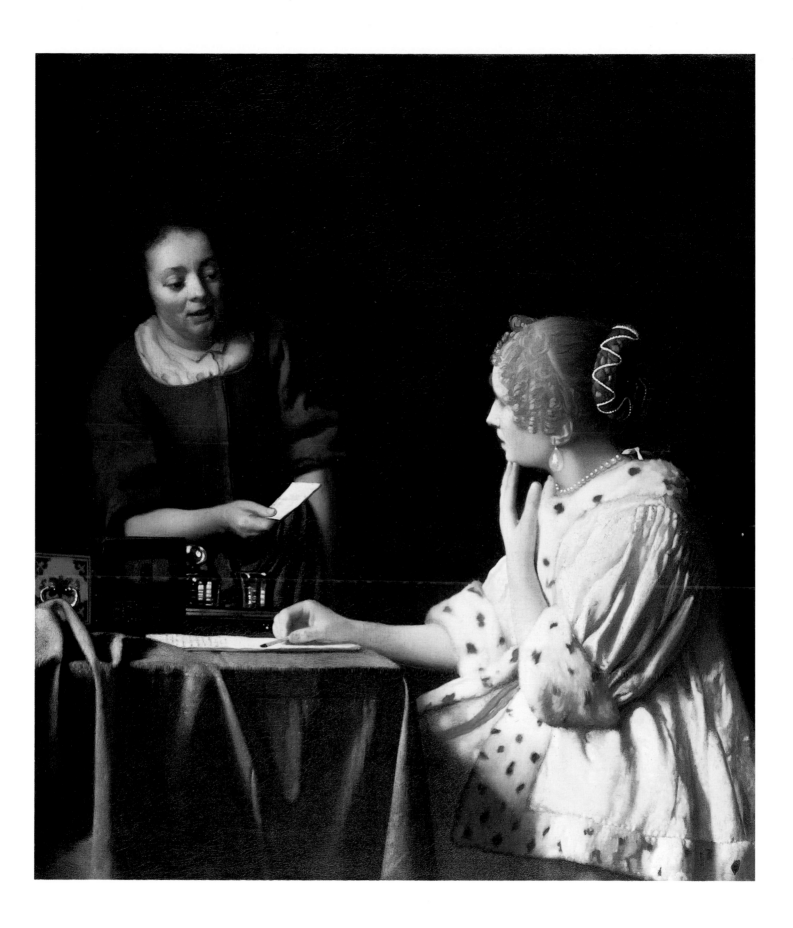

The Astronomer

1668. Oil on canvas, 50 x 45 cm. Musée du Louvre, Paris

Fig. 31
LOUIS GARREAU
The Astronomer
(after Vermeer)
1784. Engraving,
19 x 17 cm.

The Astronomer and *The Geographer* (Plate 38) are unusual among Vermeer's paintings in that they both depict a man without a female companion. They were probably pendants, that is a pair of paintings designed to hang together, since they are almost the same size and depict the same scholar in his study. The fact that the celestial and terrestrial globes depicted are a pair produced by the Amsterdam cartographer, Jodocus Hondius, strengthens the connection. The pictures appear to have been kept together until the late eighteenth century.

Both works are also dated: *The Astronomer* 1668 and *The Geographer* the following year. The date on *The Astronomer* is inscribed in Roman numerals on the cupboard, just above the scholar's hand. It is possible that the year was added by a later artist, since it does not appear in the reversed image of an engraving by Louis Garreau of 1784 (Fig. 31), but if this is the case the date is likely to have been copied from a reliable source, such as an inscription on a lost frame.

The astronomer sits at a table, bending forward to turn the celestial globe. Above the cupboard are at least ten books of various sizes, and attached to the front is a curious diagram with a large circle and two smaller circles in the upper corners, all with 'hands', but its significance is obscure. On the wall is a painting of 'The Finding of Moses', which reappears in *Lady Writing a Letter with her Maid* (Plate 43).

Vermeer's painting was acquired in the 1880s by the Paris-based banker Baron Alphonse de Rothschild. In 1940 the Nazis confiscated it from his son Édouard and Hitler ordered it to be taken to Germany. In 1945 *The Astronomer* was returned to the Rothschild family and acquired by the Musée du Louvre in 1983.

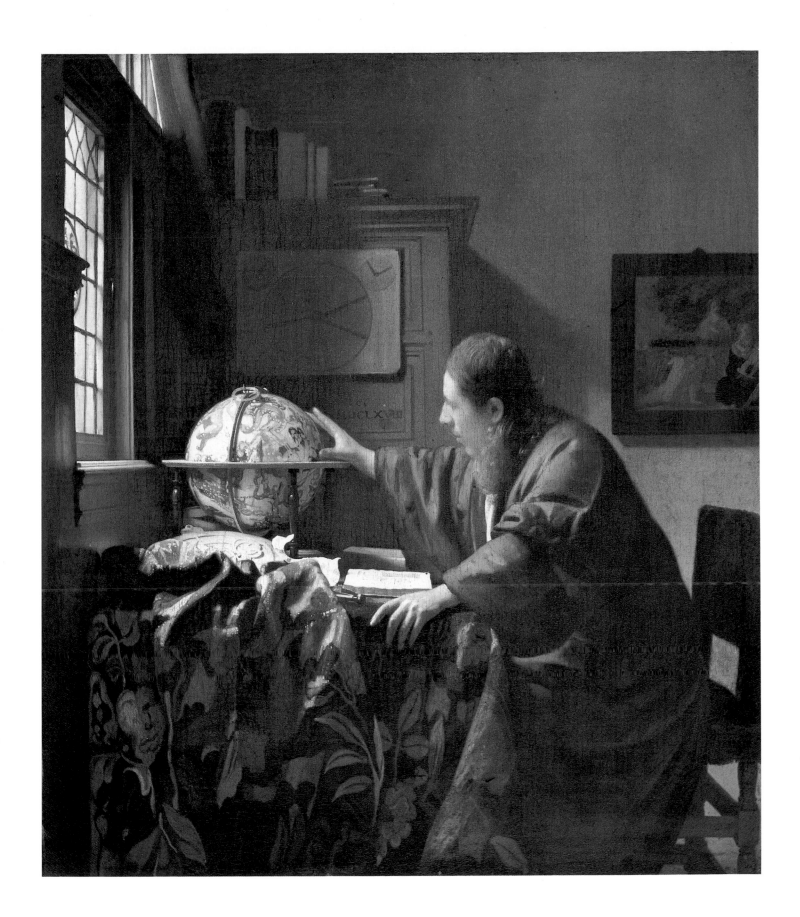

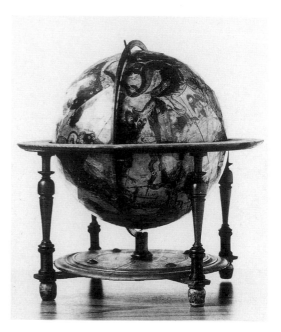

Fig. 32
JODOCUS HONDIUS
Celestial Globe
1600.
34 cm in diameter.
Nederlands
Scheepvaartmuseum,
Amsterdam

The celestial globe, which sits on a four-legged stand, was first published by Jodocus Hondius in Amsterdam in 1600 (Fig. 32). In Vermeer's painting the constellations on the upper half of the globe which face the viewer include the Great Bear on the left, the Dragon and Hercules in the centre, and Lyra on the right.

On the table lies an open book. The presence of an illustration on the left-hand page has made it possible to identify the text as the second edition of Adriaen Metius's *On the Investigation or Observation of the Stars*, published in Amsterdam in 1621. Vermeer has reproduced the first two pages of section III. The text on the right-hand page explains how 'one can learn to measure in the sky through certain geometrical instruments the situation the stars have in accordance with their longitude and latitude'. Below the globe lies a brass astrolabe, an instrument used in navigation and for measuring the position of celestial bodies, similar to that shown in the illustration on the left-hand page of the open book.

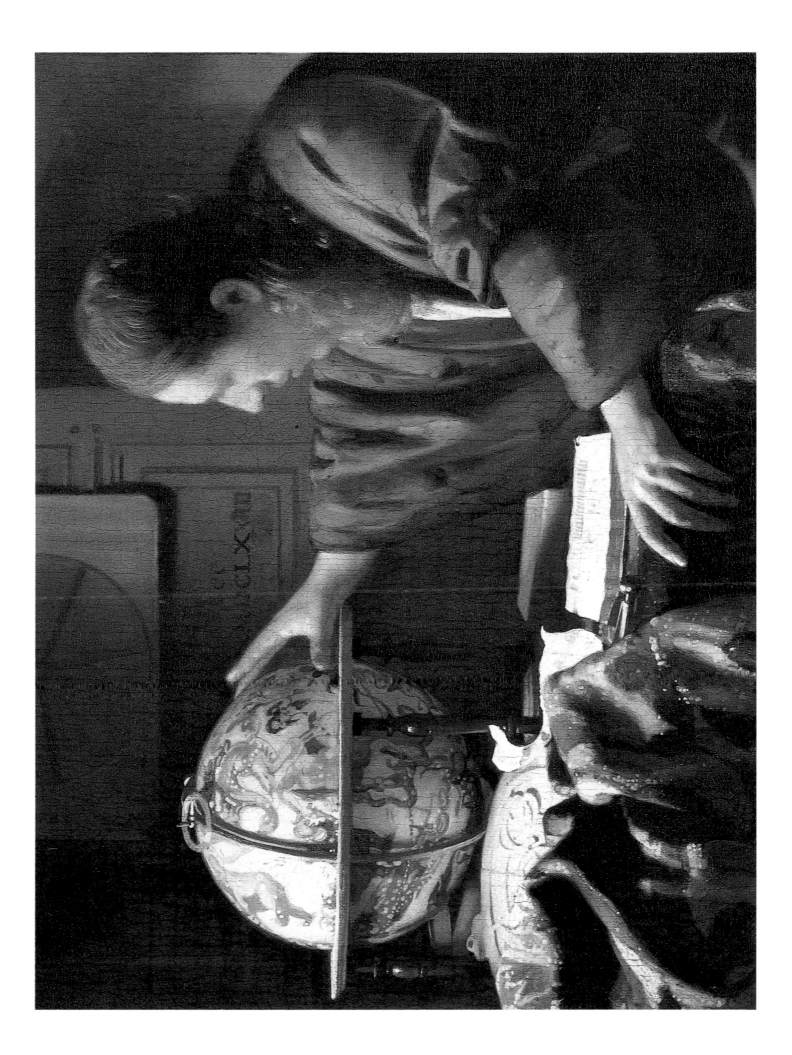

The Geographer

*c*1668–9. Oil on canvas, 53 x 47 cm. Städelsches Kunstinstitut und Städtische Galerie, Frankfurt

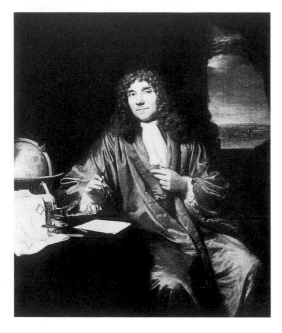

Fig. 33
JAN VERKOLJE
Portrait of Anthony
van Leeuwenhoek
*c*1680–90. Oil on canvas,
56 x 48 cm.
Rijksmuseum, Amsterdam

The geographer bends over a large unrolled map, perhaps a nautical chart. In his right hand he holds a pair of dividers, used to measure distance on a map. His eyes peer through the window and sunlight strikes the side of his face as he pauses, deep in thought. The room is noticeably brighter than the darkened interior in *The Astronomer* (Plate 36).

On top of the cupboard are a number of books and the terrestrial globe made by Hondius, with the Indian Ocean facing the viewer. Vermeer's signature is inscribed both on the cupboard and, with the year 1669, on the wall behind. The inscription on the wall was almost certainly painted in the eighteenth or nineteenth century. It may give the correct year having been copied from an accurate source although, like *The Astronomer*, it might date from the previous year.

The furnishings of the study have been slightly altered since the room was occupied by the astronomer. The ornate chair has been moved so that its back is against the wall and a stool has appeared near the table, on which rests a set square. On the floor are two rolls which are probably more charts. The painting of 'The Finding of Moses' has been replaced by a framed map of Europe, with north towards the right. Although the precise map has not been identified, it is similar to a sea chart by Willem Blaeu, which dates from the early seventeenth century.

The identity of the long-haired scholar in the two paintings remains a mystery, although it is likely to be the patron who commissioned the work. Some experts believe the man may be the scientist Anthony van Leeuwenhoek, who was born in Delft in 1632, the same year as Vermeer, and would have been about 36 when the paintings were executed. Although best known for his work in developing the microscope, Van Leeuwenhoek had a wide range of scientific interests which included navigation, astronomy and mathematics. He was appointed as administrator of Vermeer's estate after Catharina went bankrupt in 1676, although this does not necessarily prove that he was a family friend. A later portrait of Van Leeuwenhoek by the Delft painter Jan Verkolje (1650–93) (Fig. 33) also shows him with a globe, but whether or not the features are similar to the scholar in Vermeer's paintings is debatable.

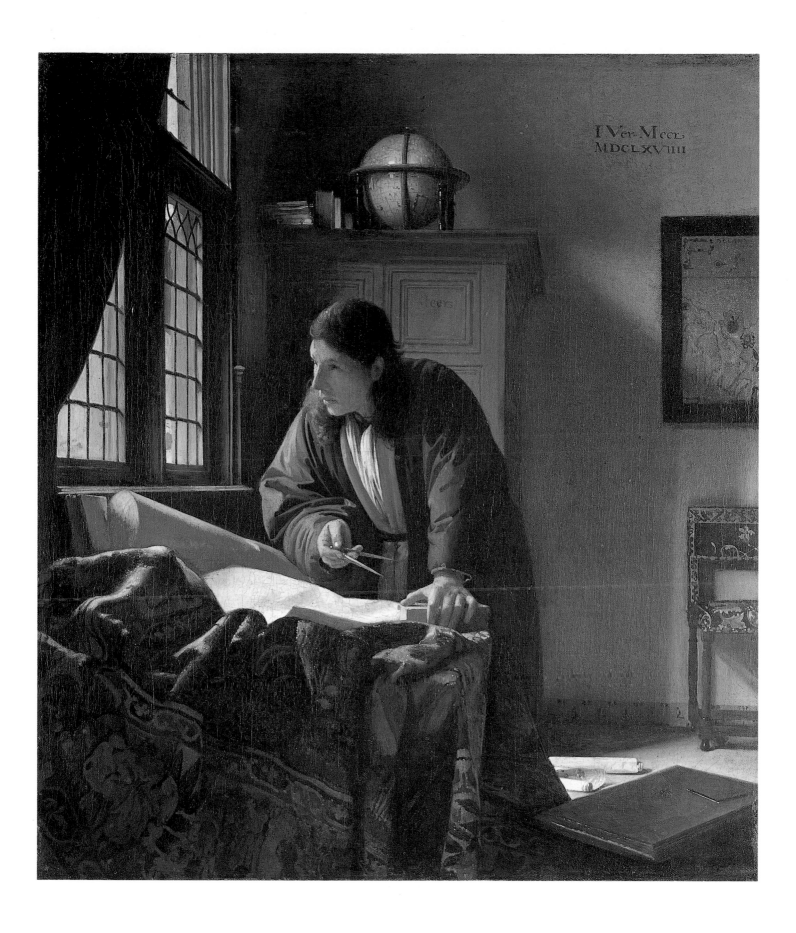

The Love Letter

*c*1669–70. Oil on canvas, 44 x 39 cm. Rijksmuseum, Amsterdam

The seated woman playing the cittern has just been interrupted by her maid, who has handed her a letter. Gold-tooled red leather runs along the lower part of the wall of this opulent room, and next to the tall fireplace hang two paintings. The lower one depicts a sailing boat, and is possibly one of the two seascapes recorded in the inventory compiled after Vermeer's death. The upper picture is a landscape with a track running alongside a wood, reminiscent of the style of Jacob van Ruisdael.

In front of the seated woman is a laundry basket and a sewing cushion for holding her sewing kit, and at the entrance to the room are a pair of slippers and a broom. The main room is viewed through a doorway, the top of which is partly covered by a tapestry drape. On the left wall, in shadow, is part of Blaeu's map of Holland and West Friesland. To the right of the doorway a piece of material is draped over the back of an ornate chair, on the seat of which lies a musical score.

The two women may be the same models as those in *Mistress and Maid* (Plate 35). As in this earlier work, Vermeer has used the presence of a letter to raise the question of the mistress' relationship with her absent lover. In both paintings, the presence of the letter and the concerned expression of the mistress hint at a complicated love affair.

The Love Letter was stolen on 24 September 1971, while on loan to an exhibition in Brussels, but it was recovered 13 days later.

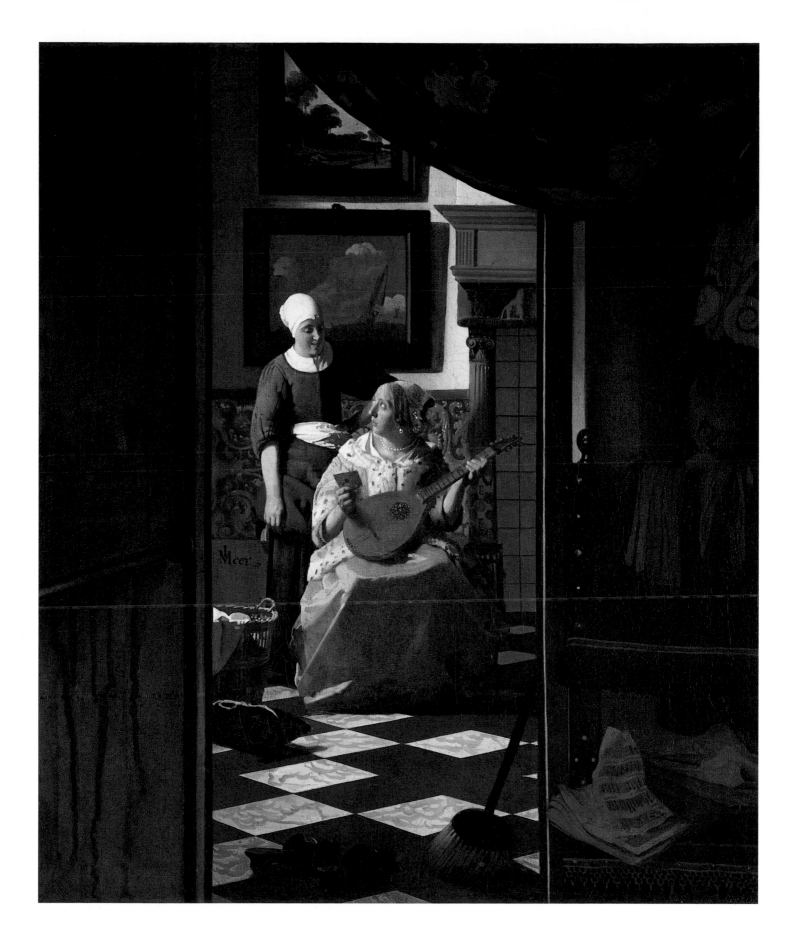

The letter is unopened as the seal on the back remains intact, but the mistress apparently recognizes the handwriting since she looks up with a worried expression. Although the maid seems unconcerned, there is a slightly conspiratorial air as they exchange knowing looks.

The Love Letter shares several similarities with *Woman Reading a Letter* by Gabriel Metsu (Fig. 34). In both paintings the women are similarly dressed; the maids wear dark brown blouses with blue aprons, while the mistresses have yellow jackets fringed with white fur. There is also a seascape in each painting, although Metsu's scene is much stormier. Like the main room in Vermeer's work, *Woman Reading a Letter* is crisply painted in bright colours. Although neither work is dated it is more likely that the Metsu is a few years earlier than the Vermeer.

Fig. 34
GABRIEL METSU
Woman Reading a
Letter
*c*1663. Oil on canvas,
52 x 41 cm.
National Gallery of
Ireland, Dublin

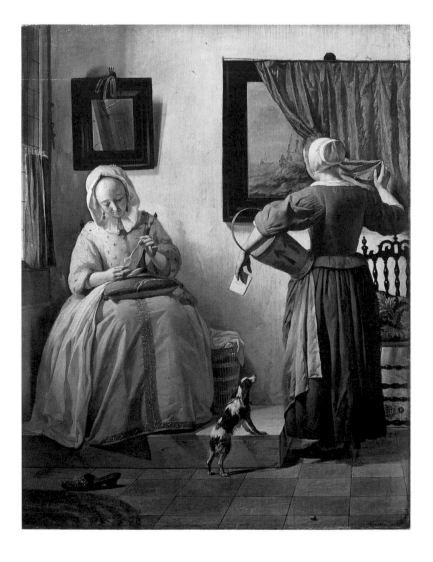

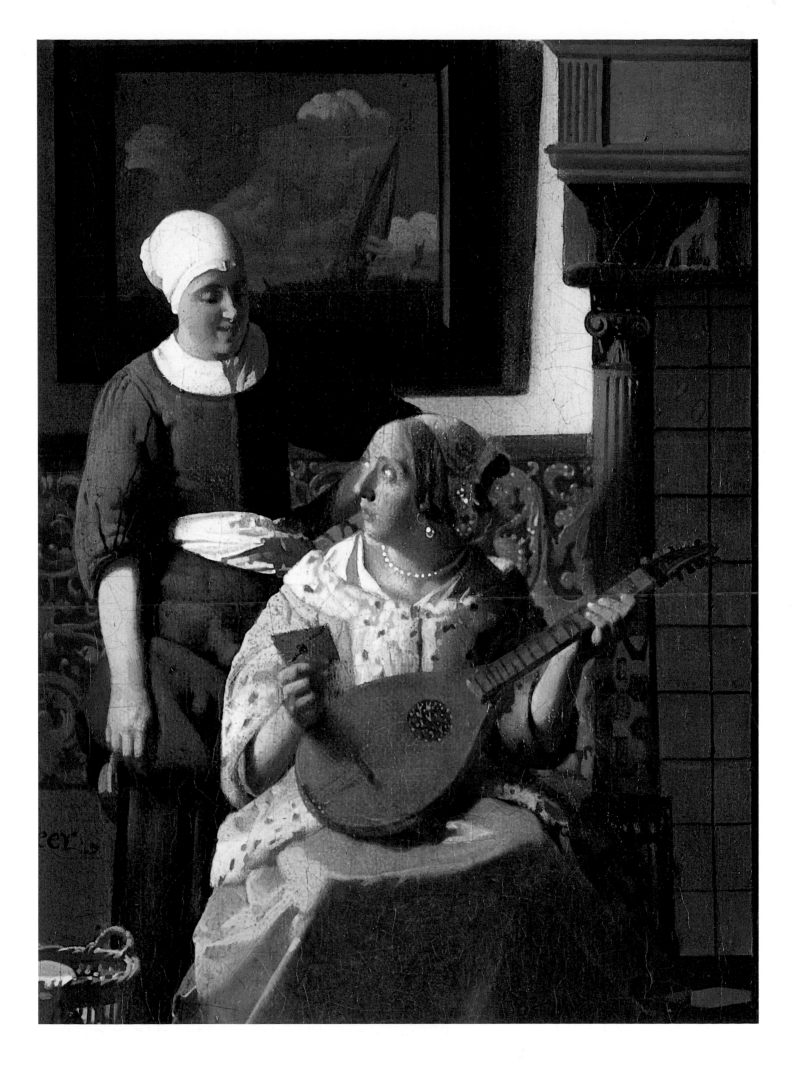

The Lacemaker

*c*1669–70. Oil on canvas, 25 x 21 cm. Musée du Louvre, Paris

Vermeer's painting is small, but very meticulously executed and the artist must have worked with similar dexterity to the lacemaker in his picture. The young woman bends over her work, concentrating intently on the lace. Her face is softly rendered, part of it lit by warm sunlight and the rest in shadow. Over her yellow dress she wears a lace collar, presumably the fruits of her labour.

The lacemaker sits at a complicated piece of furniture, a triangular table, the surface of which could be raised at an angle and secured by means of the single leg with the knob top. Next to this, on the carpet-covered table, are a thick book with light-coloured binding secured by tapes, and the girl's sewing cushion, decorated with tassels at the corners. The top of the cushion would open to reveal compartments in which sewing equipment was stored; while sewing, the girl would rest the cushion on her lap to provide a comfortable base on which to work.

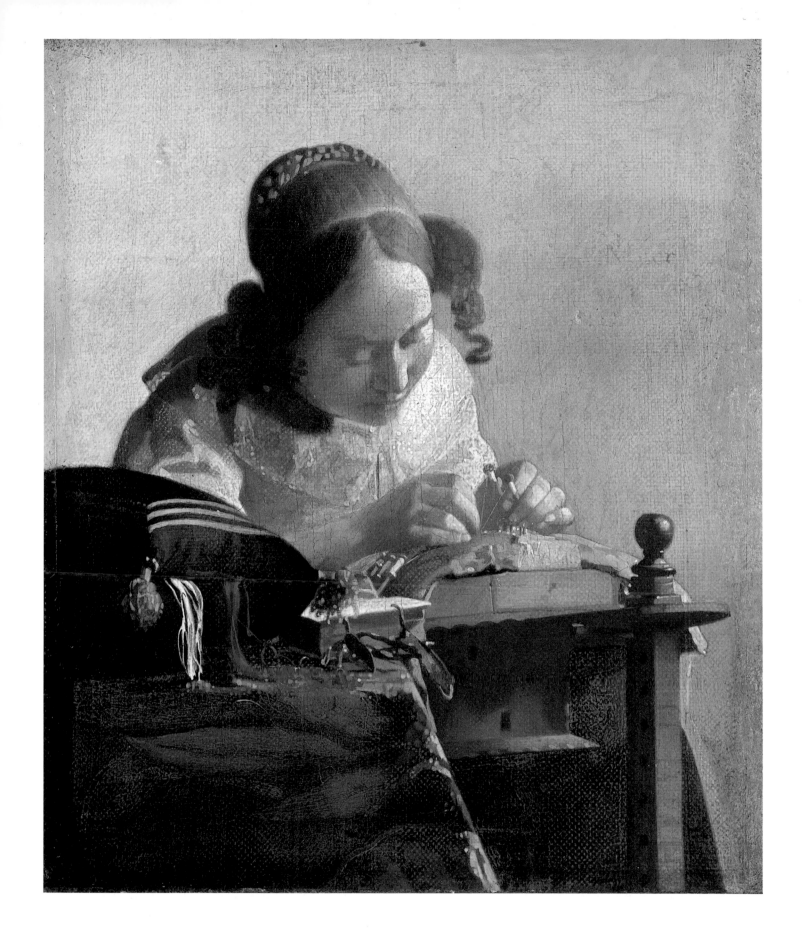

With her left hand the girl holds the two bobbins, from which the threads form a V-shape that draws the viewer's eye to the spot where the lace is being made. Three more bobbins are visible to the side of her right hand which hides the pin she is using to make the lace.

One of the most extraordinary aspects of Vermeer's picture is the way the red threads appear to be flowing out of the sewing cushion. The fact that these threads are blurred helps to focus attention on the lacemaker, particularly the delicate task she is performing with her hands, and our eye keeps returning to the spot where the lace is being so carefully made.

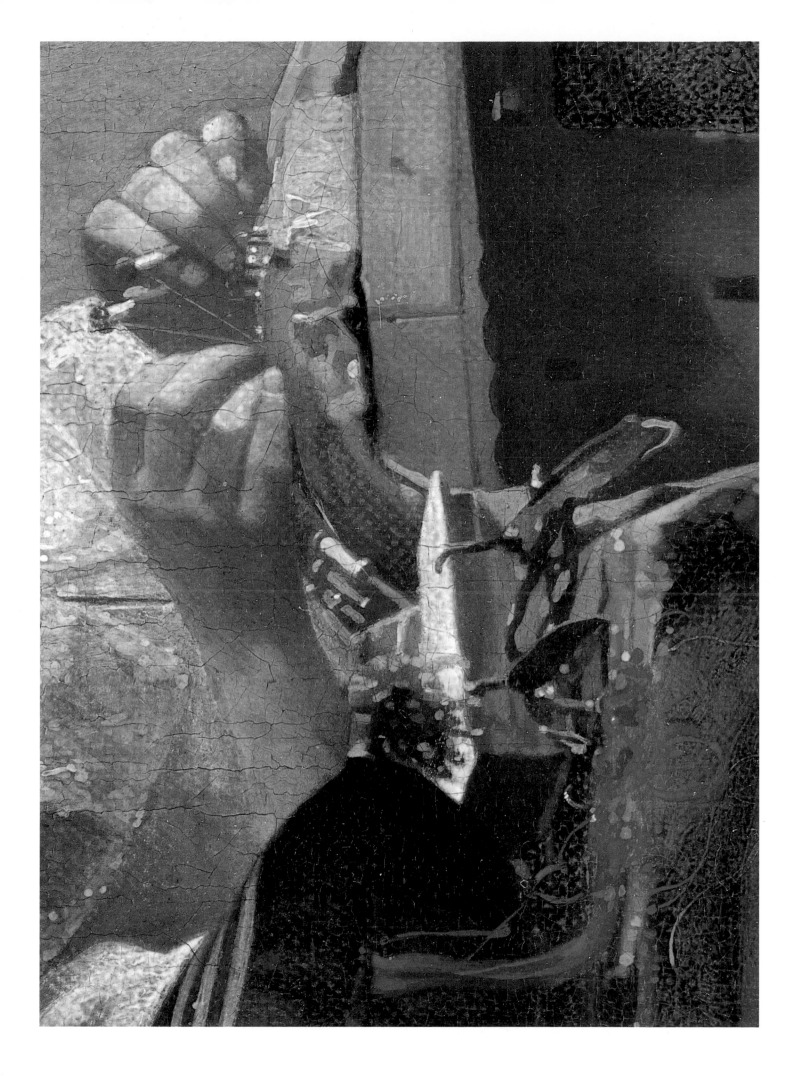

Lady Writing a Letter with her Maid

*c*1670. Oil on canvas, 71 x 58 cm. National Gallery of Ireland, Dublin

The woman sits at the table, absorbed in writing a letter. Her maid stands patiently with her arms crossed, gazing out of the leaded window, presumably waiting for her mistress to finish the letter which she will then deliver. A crumpled page lies on the floor, although it is unclear whether this is an unwelcome letter that she has just received or an earlier version of her own letter which she has discarded.

The large painting on the rear wall is of 'The Finding of Moses', the subject taken from the story in Exodus which describes how the infant Moses was found near the bank of the Nile. Here Moses is shown after his rescue, surrounded by the Pharoah's daughter and her handmaidens. The same painting appears in a smaller scale in the background of *The Astronomer* (Plate 36). It is unclear who might be the original artist of 'The Finding of Moses', but it could possibly be an early work of Vermeer because of its stylistic similarities to *Diana and her Companions* (Plate 3).

Lady Writing a Letter with her Maid was owned by Sir Alfred Beit, the former British Member of Parliament who died in 1994. It was hung at Russborough House, near Blessington in Ireland, from where it was stolen twice. It was first taken on 26 April 1974, when it was among 18 pictures stolen by a gang connected to the IRA. The Vermeer was recovered eight days later, almost undamaged. On 21 May 1986 the painting was stolen a second time, with 17 others, and recovered in Antwerp on 2 September 1993. Sir Alfred presented a number of paintings to the National Gallery of Ireland in 1987, including the Vermeer in the event that it was recovered and it is now in the Irish national collection.

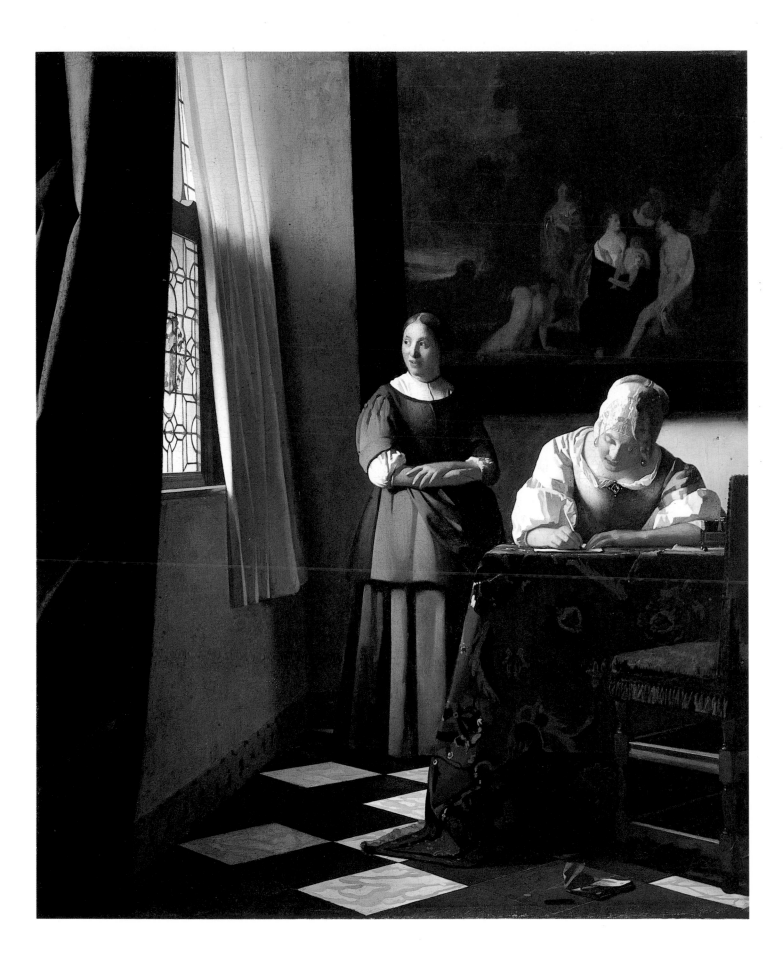

Allegory of Faith

*c*1671–4. Oil on canvas, 114 x 89 cm. Metropolitan Museum of Art, New York

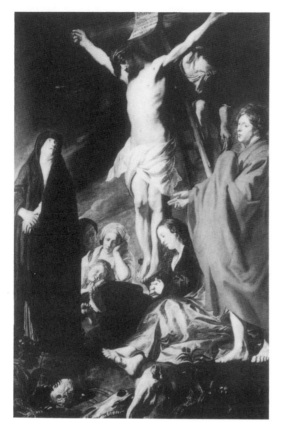

Fig. 35
JACOB JORDAENS
Crucifixion
Early 1620s. Oil on canvas,
310 x 197 cm.
Terningh Foundation,
Antwerp

This unusual Vermeer represents an allegory of Catholic faith. The figure of Faith is depicted in a theatrical pose, clutching her hand to her breast, her eyes gazing upwards and her right foot resting on a globe. She is loosely based on the symbolic representation from Ripa's *Iconology* in which Faith is described as 'a seated lady ... her feet resting on Earth'. Vermeer's picture is somewhat contrived, and painted in the very polished style that was popularized by the 'fine' painters of Leiden, such as Dou and Van Mieris (Figs. 19, 23, 26 and 37).

On the altar-like table of *Allegory of Faith* lie a chalice and an open Bible. There is also a crucifix, quite possibly the 'ebony wood crucifix' listed in the inventory drawn up after Vermeer's death. The terrestrial globe is the same as that depicted in *The Geographer* (Plate 38), by Hondius, and Faith rests her foot on the continent of Asia. On the floor lies a bitten apple, representing sin. The twisted serpent has been crushed by a stone and blood spurts from its mouth, a fate which symbolizes the victory of good over evil.

The painting on the back wall is a slightly simplified version of the *Crucifixion* by Jacob Jordaens, a version of which survives in Antwerp (Fig. 35). Vermeer has omitted both the man on the ladder and Mary Magdalene at the feet of Christ, presumably to avoid undue distraction from the figure of Faith. Vermeer's family may have owned the Jordaens, or a copy of it, since the 1676 inventory includes a 'large painting representing Christ on the Cross'.

The Art of Painting (Plate 32) must have served as a prototype for *Allegory of Faith*, which was probably commissioned by a Catholic patron who had admired the earlier work. Both allegories are set in the same room, with its beamed ceiling, marble floor tiles and tapestry curtain. It is interesting that although *Allegory of Faith* was obviously intended for a Catholic patron, it was soon acquired by a Protestant collector. In 1699 it was sold by the Protestant banker Herman van Swoll, who had presumably obtained it as an example of a 'fine' painting.

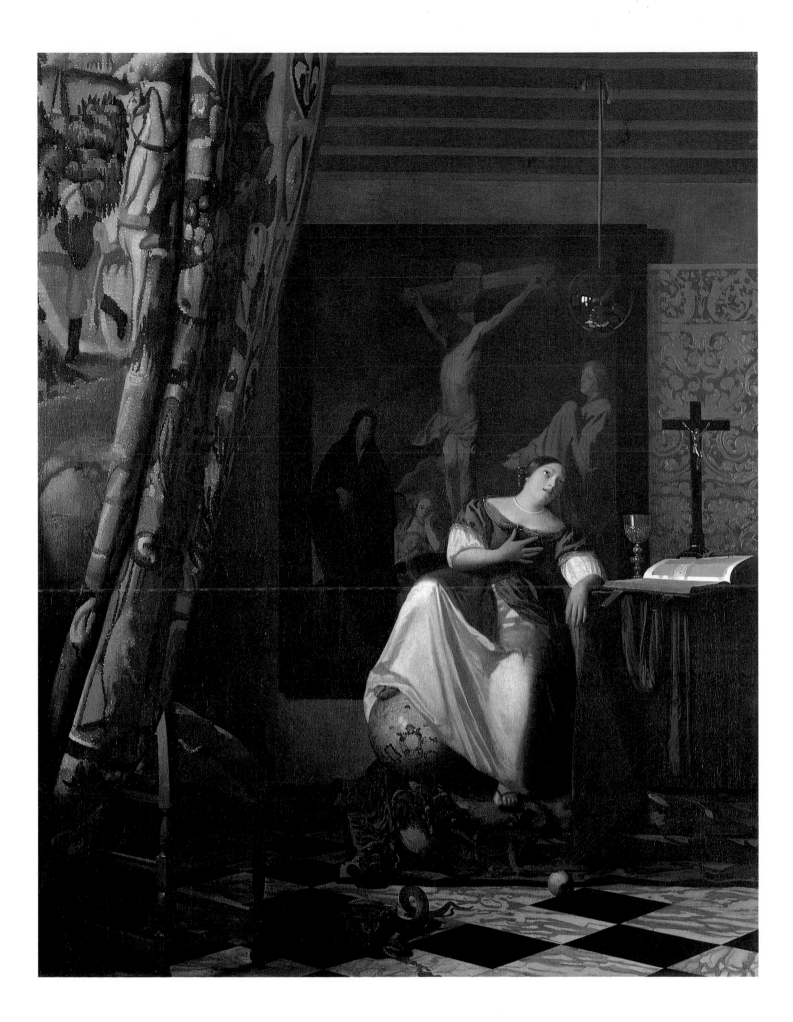

45　The Guitar Player

*c*1672. Oil on canvas, 53 x 46 cm. Iveagh Bequest, Kenwood, London

The radiant young woman plays an early type of guitar, which has a more slender body than the modern instrument. Vermeer's composition is daring; the girl is positioned off-centre and her right elbow is actually cut out of the picture altogether. The woman turns to her right with a warm smile as though she is looking into the eyes of a companion; perhaps her lover is beside her, enjoying her harmonious music. The painting on the wall is a pastoral landscape showing a small clump of trees, reminiscent of the style of Adriaen van de Velde (1636–72), and this adds to the mood of tranquility.

The Guitar Player was stolen from Kenwood House on 23 February 1974 by supporters of the IRA and recovered in a churchyard in Smithfield, London, ten weeks later.

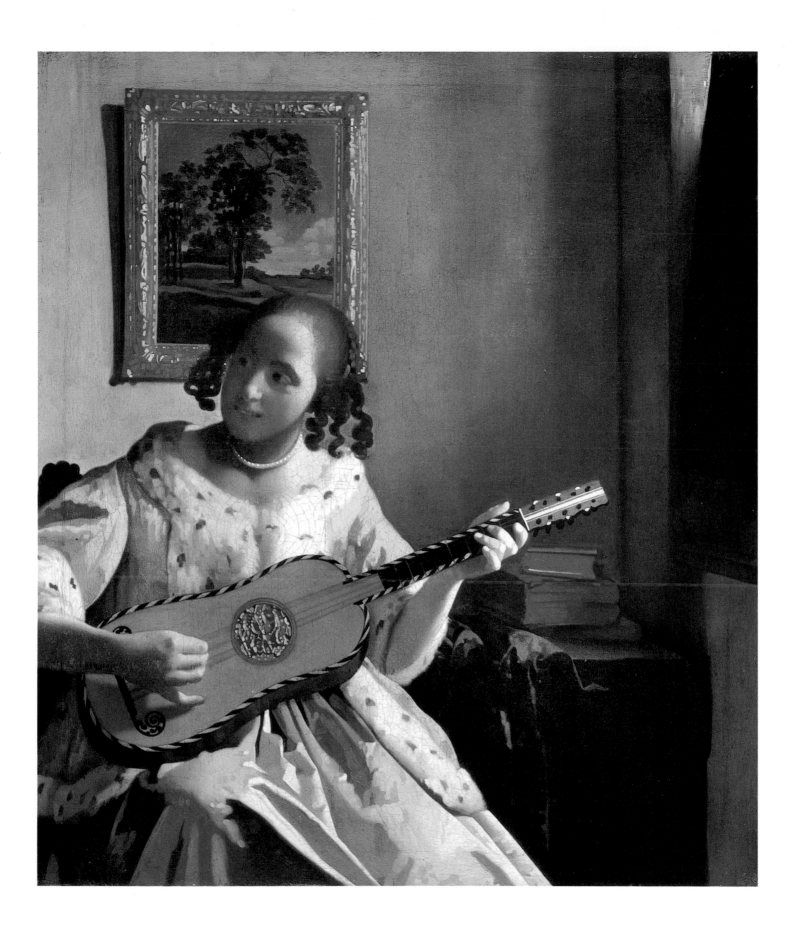

*c*1673–5. Oil on canvas, 52 x 45 cm. National Gallery, London

The young woman playing the virginal seems to recognize the person who has presumably just entered the room, and smiles. Perhaps it is a man who will come and sit beside her on the vacant chair.

On the painted underside of the virginal's lid part of a landscape can be seen. There is also a small landscape picture hanging on the wall in the style of Jan Wynants (active 1643–84). The larger picture of Cupid is thought to have been inspired by an engraved emblematic image by Otto van Veen (1556–1629), captioned 'Perfect Love is only for One' (Fig. 36). Cupid holding a card showing the number one or an ace was a symbol of fidelity. Vermeer also depicted similar paintings of Cupid in the backgrounds of *A Girl Asleep* (Plate 6) and *Girl Interrupted at her Music* (Plate 17), and an X-ray examination reveals that he originally intended to include one in *Girl Reading a Letter at an Open Window* (Plate 7). It is possible that these represent the 'Cupid', by an unknown artist, which is listed in the inventory made after Vermeer's death.

Fig. 36
OTTO VAN VEEN
Cupid (Perfectus
Amor Est Nisi ad
Unum)
1608. Engraving.
From *Amorum Emblemata*
(Antwerp, 1608)

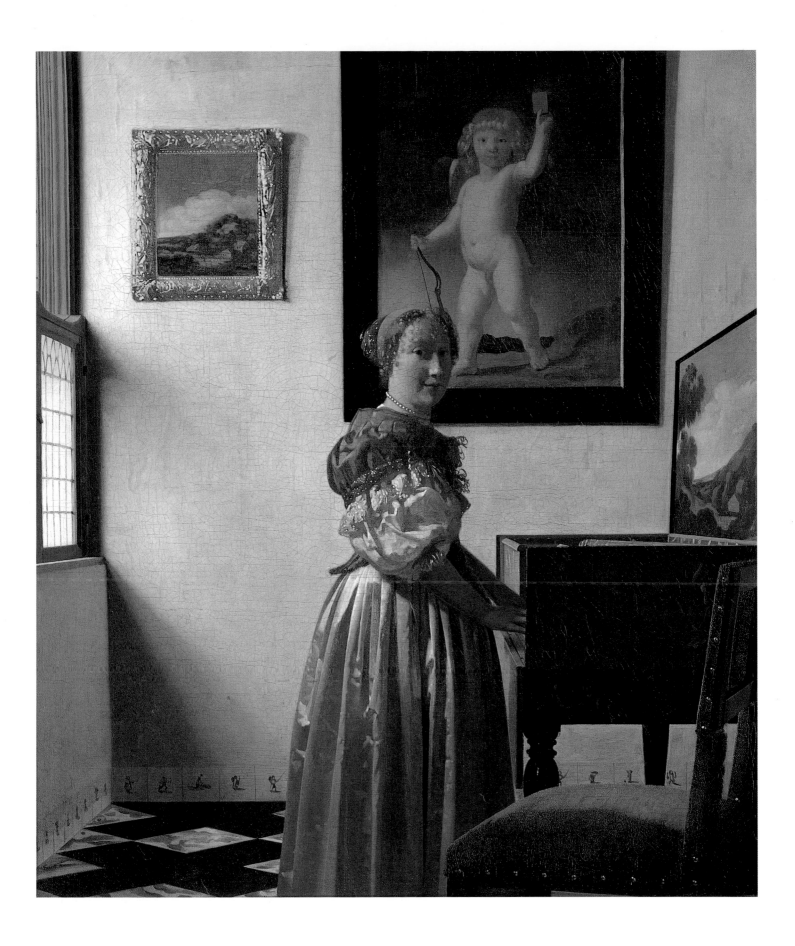

47 A Lady Standing at the Virginal
(detail of Plate 46)

The elegant woman wears an opulent silk dress, covered with a blue bodice, and her billowing sleeves are fringed with several red bows. In her hair she has small metal ornaments which fall over her forehead in the fashion of the 1660s. Like most of Vermeer's women, she is adorned with a pearl necklace. These pearls are partly symbols of vanity – a representation of worldly riches and a reminder of the conflict between virtue and vice. But like so much in Vermeer's paintings, they have no straightforward meaning and are also included simply to add beauty and give pleasure to the viewer.

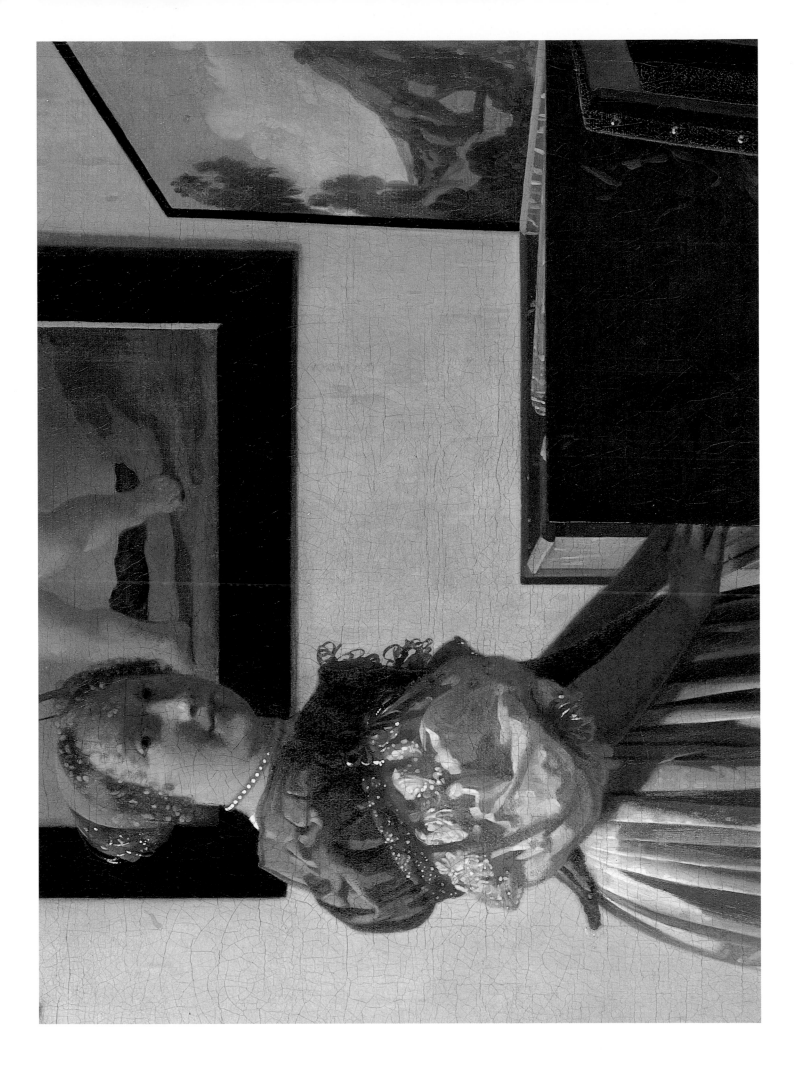

A Lady Seated at the Virginal

*c*1673–5. Oil on canvas, 52 x 46 cm. National Gallery, London

Fig. 37
GERARD DOU
Woman Playing the
Virginal
*c*1665. Oil on canvas,
37 x 28 cm.
Dulwich Picture Gallery,
London

This is probably Vermeer's last surviving painting, which may have been inspired by Dou's *Woman Playing the Virginal* (Fig. 37), dating from a few years earlier.

A young woman sits at a virginal, her music before her, and turns to the viewer with an enigmatic look. Although the virginal is very similar to the instrument in *A Lady Standing at the Virginal* (Plate 46), it has a different landscape scene depicted on the underside of the lid. Resting beside the virginal is a viol with the bow in the strings, ready to be played.

The painting on the back wall is *The Procuress* by Van Baburen (Fig. 30), here framed in gold, compared with its earlier representation in *The Concert* (Plate 31), where it is depicted in an ebony frame. This picture, symbolizing mercenary love, is in contrast to the faithful love of Cupid represented in *A Lady Standing at the Virginal*.

There is an ongoing debate over whether this painting and *A Lady Standing at the Virginal* are pendants and were intended to hang together. The two women are dressed in similar clothing and both turn to look at the viewer. The paintings are virtually the same size, and the fact that the women face in opposite directions means they make a pleasing pair. However, for the paintings to be pendants, they would normally have to date from the same period, and some experts, such as Blankert, believe that *A Lady Standing at the Virginal* is earlier, dating from 1670.

After Vermeer's death the two pictures do not seem to have been kept together, and it was only in 1867 that they were eventually reunited by Thoré. They were separated again in 1892 when *Lady Standing at the Virginal* was bought by the National Gallery. This painting was acquired by George Salting in the late 1890s and bequeathed to the National Gallery in 1910. Since then the two pictures, which are among Vermeer's last works, once more hang together.

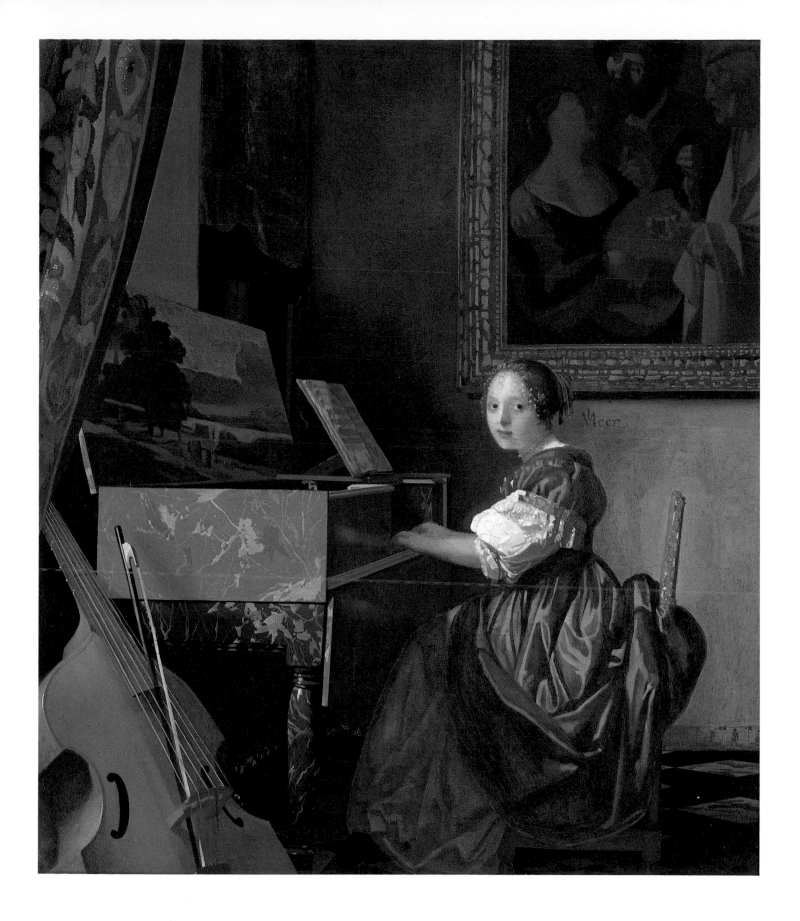

PHAIDON COLOUR LIBRARY
Titles in the series

FRA ANGELICO	BONNARD	BRUEGEL	CANALETTO	CARAVAGGIO	CEZANNE	CHAGALL	CHARDIN	CONSTABLE
Christopher Lloyd	Julian Bell	Keith Roberts	Christopher Baker	Timothy Wilson-Smith	Catherine Dean	Gill Polonsky	Gabriel Naughton	John Sunderland

CUBISM	DALÍ	DEGAS	DÜRER	DUTCH PAINTING	ERNST	GAINSBOROUGH	GAUGUIN	GOYA
Philip Cooper	Christopher Masters	Keith Roberts	Martin Bailey	Christopher Brown	Ian Turpin	Nicola Kalinsky	Alan Bowness	Enriqueta Harris

HOLBEIN	IMPRESSIONISM	ITALIAN RENAISSANCE PAINTING	JAPANESE COLOUR PRINTS	KLEE	KLIMT	MAGRITTE	MANET	MATISSE
Helen Langdon	Mark Powell-Jones	Sara Elliott	J. Hillier	Douglas Hall	Catherine Dean	Richard Calvocoressi	John Richardson	Nicholas Watkins

MODIGLIANI	MONET	MUNCH	PICASSO	PISSARRO	POP ART	THE PRE-RAPHAELITES	REMBRANDT	RENOIR
Douglas Hall	John House	John Boulton Smith	Roland Penrose	Christopher Lloyd	Jamie James	Andrea Rose	Michael Kitson	William Gaunt

ROSSETTI	SCHIELE	SISLEY	SURREALIST PAINTING	TOULOUSE-LAUTREC	TURNER	VAN GOGH	VERMEER	WHISTLER
David Rodgers	Christopher Short	Richard Shone	Simon Wilson	Edward Lucie-Smith	William Gaunt	Wilhelm Uhde	Martin Bailey	Frances Spalding